IMAGES
of America

HISTORIC SIGNS
of SAVANNAH

PHOTOGRAPHS FROM THE COLLECTION OF
THE GEORGIA HISTORICAL SOCIETY

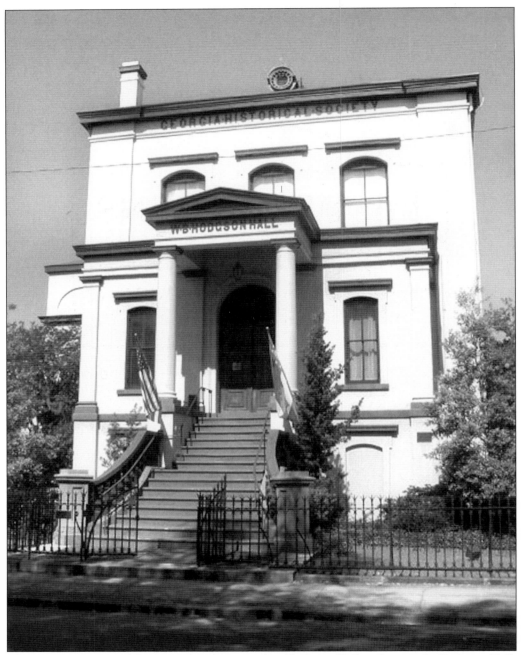

The Georgia Historical Society is headquartered in Hodgson Hall in Savannah. Hodgson Hall, named for William B. Hodgson, became the third home of the Society in September 1875. The building was officially dedicated on February 14, 1876, and has been the Society's statewide headquarters ever since. Housed within Hodgson Hall is one of the finest library collections of manuscripts, archives, books, photographs, newspapers, architectural drawings, portraits, maps, and artifacts relating to the state of Georgia. Hodgson Hall is located at 501 Whitaker Street, Savannah, Georgia, 31401.

IMAGES
of America

HISTORIC SIGNS
of SAVANNAH

PHOTOGRAPHS FROM THE COLLECTION OF
THE GEORGIA HISTORICAL SOCIETY

Justin Gunther

ARCADIA

Published by Arcadia Publishing
Charleston SC, Chicago IL, Portsmouth NH, San Francisco CA

Printed in Great Britain

Library of Congress Catalog Card Number: 2004107553

For all general information contact Arcadia Publishing at:
Telephone 843-853-2070
Fax 843-853-0044
E-mail sales@arcadiapublishing.com
For customer service and orders:
Toll-Free 1-888-313-2665

Visit us on the internet at http://www.arcadiapublishing.com

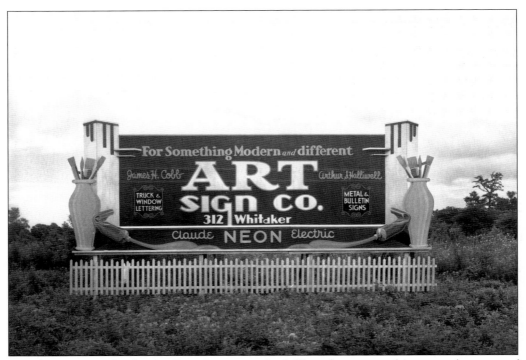

An advertisement for the Art Sign Company, this billboard gives us information about one of the businesses responsible for creating the signs of Savannah. Owners James H. Cobb and Arthur S. Halliwell operated a shop at 312 Whitaker Street. They lettered trucks and windows and manufactured metal and bulletin signs. In addition to painting signs, the company could electrify signs with neon. (Cordray-Foltz Collection #1360, Box 6, Folder 1, Item 1.)

CONTENTS

The Georgia Historical Society 6

Acknowledgments 7

Introduction 8

1. Retailers 9

2. Home Goods and Hardware 33

3. Trades and Services 43

4. Food Markets and Manufacturers 55

5. Restaurants and Bars 73

6. Drugs and Tobacco 85

7. Theaters 95

8. Hotels and Motels 105

9. Shipping and Industry 113

10. Transportation 117

Index 127

THE GEORGIA HISTORICAL SOCIETY

Chartered by the Georgia Legislature in 1839, the Georgia Historical Society is a private, non-profit organization that serves as the historical society for the entire state of Georgia. For more than 160 years, the Society has fulfilled its mission to collect, preserve, and share Georgia's history through the operation of its library and archives in Savannah. The Society exists to tell the story of our state's journey through time and to give our citizens a sense of who we are as Georgians.

The Georgia Historical Society is headquartered in Savannah in historic Hodgson Hall and is a major research center serving approximately 10,000 researchers of Georgia history per year. Within the Society's library and archives is preserved one of the most outstanding collections of manuscripts, books, photographs, newspapers, architectural drawings, portraits, maps, and artifacts related to Georgia history anywhere in the country. The Society is continually adding to its collections through both donations and purchases.

In addition to its magnificent library, the Georgia Historical Society has a statewide outreach program. The Society accomplishes this mission in a variety of ways and to a wide audience. The Society conducts lectures and historical programs, administers the State Historical Marker Program, and most significantly, has a statewide Affiliate Chapter Program. This program is the foundation upon which all statewide outreach is built.

The Affiliate Chapter Program encourages historical agencies and interested parties throughout the state to join the Georgia Historical Society in our mission to save Georgia history. Through this professional education program, the Society provides assistance, holds teacher workshops, and serves as an information clearinghouse for those historical agencies in need of help or advice. Staff members visit these organizations and conduct consultation visits offering assistance in everything from archival management and administration to securing grant funds. The Affiliate Chapter Program, more specifically the workshops conducted as part of the program, was awarded the 1997 Professional Development Program of the Year by the Georgia Association of Museums and Galleries.

In addition to the Affiliate Chapter Program, the Georgia Historical Society organizes the Georgia Heritage Celebration, which is held every February and is a time for us to remember the founding of our state. The celebration is directed at schoolchildren with research and colonial costume workshops, colonial town meetings, and a parade from Forsyth Park up Bull Street to City Hall.

The Georgia Historical Society publishes the *Georgia Historical Quarterly* with cooperation from the Georgia College and State University in Milledgeville. The *Georgia Historical Quarterly* has become one of the country's leading scholarly journals dedicated to a particular state. In 1840, the Society began publishing books with items from the collection. This is an ongoing activity at the Georgia Historical Society, and this book is a continuation of that program.

ACKNOWLEDGMENTS

The author would like to thank the staff of the Georgia Historical Society, especially Jewell Anderson, Susan Dick Hoffius, Mandi Johnson, and Mary Murphy, for their assistance with this project. The Society's wealth of resources and its employees' enthusiastic support made this book a reality.

The Historic Savannah Foundation's Casey Grier and Mark McDonald graciously offered their archives for research. Photographs used from the Historic Savannah Foundation are noted throughout the book. The friendship and hospitality of all the Foundation's employees made researching there enjoyable.

I thank Stratton and Mary Leopold for providing photographs of Leopold's Ice Cream, their family's business. After being closed for decades, the couple has reopened the Savannah institution. I wish them the best of luck.

In addition, my appreciation extends to my family for their love and pride, my mother for her valuable help and advice, Jeremy Spencer for his constant encouragement, Prof. Jim Abraham at the Savannah College of Art and Design for his thoughtful guidance, and Dr. Charles Brownell at Virginia Commonwealth University for his enthusiastic support. I am also grateful to the following people and organizations: Joga Ivatury, Kunoor Jain, Carmie Jones, Jay Khosla, Keith MacKay, Jonathan Mellon, Beth and Clay Perdue, Kim Peterka, Dhanya Puram, Jennifer Sandy, all my classmates and teachers at the Savannah College of Art and Design, the Historic Richmond Foundation, the Davenport House Museum, and the Savannah community.

INTRODUCTION

Signs are everywhere, and they play an important role in human existence. They identify services and are a fundamental element of trade, commerce, and industry. Signs allow the owner to communicate with the viewer, creating the link between seller and consumer. More importantly, signs speak of the people who run the businesses. Signs are essentially social markers, signatures of their owners' personalities and tastes. A simple rectilinear sign painted black and white might represent frugality, a star might symbolize a commitment to quality, and a unique ornamental detail might convey an owner's desire for individuality and retail superiority. In addition, signs reflect the ethnic makeup and character of a neighborhood, giving insight into an area's social and business activities.

Historic signs speak about the past in ways that buildings by themselves cannot. They add another layer of importance to a building's historical significance by identifying a structure's social purpose. And as signs vary, different stages in a building's history are identified. Changing signs reflect evolving business practices, the desire to promote a new image, or different ownership. In this respect, signs are like archeological layers giving evidence of sequential periods of human use and occupancy.

Historic Signs of Savannah presents images of the city's historic signage, giving readers concrete details about daily life in a former era. The book's photographs, postcards, and advertisements show signs of all types, ranging from brick wall paintings to neon. These signs communicate names, addresses, products, prices, and fragments from another time, bringing the businesses and industries of Savannah's past back to life. The diversity of signs examined gives a comprehensive understanding of commercial Savannah during the time period spanning from the late 19th century to the mid-20th century. Following each caption is a citation in parentheses to assist readers in locating these images. Also, to maintain historical accuracy, Martin Luther King Jr. Boulevard is referred to as West Broad Street throughout the text.

One of the main purposes of this book is to raise awareness for the preservation of historic signs. Planners and developers usually ignore signs, viewing their contribution to historic environments as minimal or insignificant. Signs are often discarded without consideration. However, these commercial artifacts deserve recognition and add to the character of historic streetscapes. If a building has historic signage, the modern-day owner should think of creative ways to incorporate that signage into their business's image. City zoning ordinances should make allowances for the continued use of historic signs and prevent controls imposing a standard sign image that contradicts the visual diversity of the past. Hopefully, this book will excite Savannahians to preserve their historic signs and save these cultural icons for future generations to enjoy.

One
RETAILERS

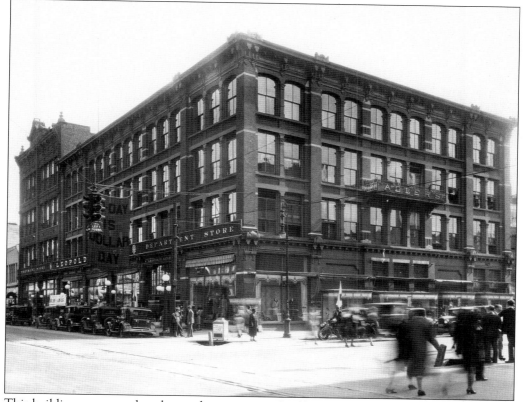

This building once stood at the southeast corner of Bull and Broughton Streets. Built in 1885, it was originally home to the A.R. Altmayer Company. Through years of hard work, Leopold Adler became a partner in the department store. He purchased the store in 1892 and renamed the business Adler's Department Store. Under Adler's guidance, the store grew and became one of the Southeast's great department stores. (Cordray-Foltz Collection #1360, Box 6, Folder 3, Item 1.)

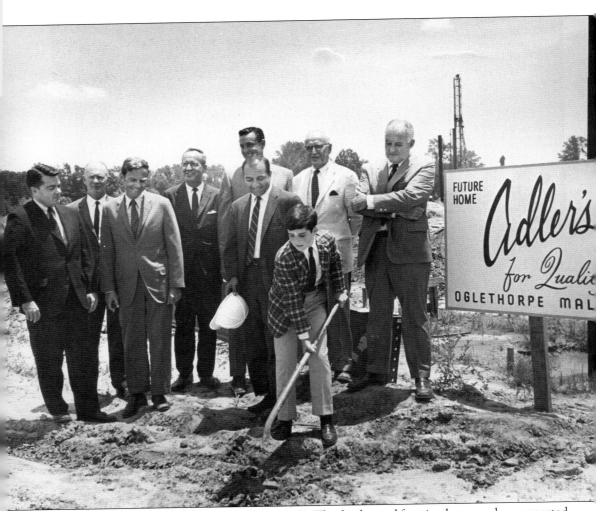

The Broughton Street building burned in 1958. The fire burned for nine hours and was reported as the worst downtown fire since 1889. A new store was erected on the site for J.C. Penney. The building at the corner today is an extensive remodeling of the Penney's department store. After temporary locations, Adler's moved to the Victory Shopping Plaza. In 1968 Adler's announced its plans to build a new store at the Oglethorpe Mall Shopping Center. Young Robert Adler turned a ceremonial shovel of dirt during the groundbreaking ceremonies on July 18. Watching Robert, from left to right, are John Singleton, president of Scott Hudgens Properties, mall developers; Hunter Saussy, senior vice president of Savannah Bank and Trust; Meyer Fluke, vice president of Adler's; Sam Adler Jr., president of Adler's and Robert's father; Scott Hudgens, developer of Oglethorpe City; Sandy Simon, project manager for Oglethorpe City; Sam Adler Sr., chairman of the board of Adler's, and Malcolm Bell, Savannah Bank president. (GHS Photo Collection #1361 PH, Box 8, Folder 1, Item 1438.)

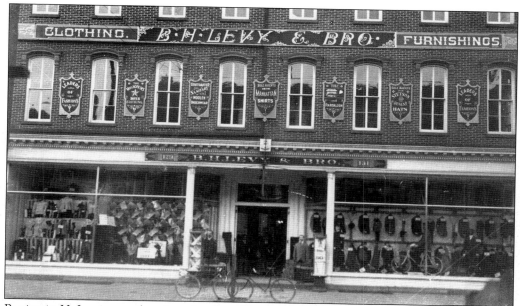

Benjamin H. Levy moved to America from France in 1867. In the fall of 1871 he opened B.H. Levy, General Merchandise, at the corner of Bryan and Jefferson Streets. His brother Henry Levy later came to Savannah and became a partner in the firm in 1878. After several moves, the company relocated in 1895 to the store pictured above on Broughton just west of Bull Street. (GHS Photo Collection #1361 PH, Box 9, Folder 1, Item 1697.)

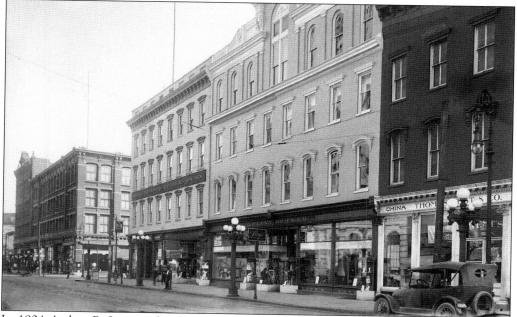

In 1904 Arthur B. Levy and Sidney H. Levy were admitted to the firm, and the name was changed to B.H. Levy, Bro. & Co. The store originally catered exclusively to men and boys. Early success led to the addition of a fourth story devoted entirely to women's outerwear. (Cordray-Foltz Collection #1360, Box 10, Folder 7, Item 16.)

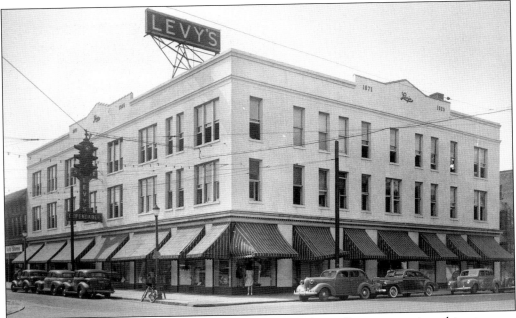

Levy's moved to the corner of Abercorn and Broughton Streets, opening this store on September 10, 1925. For the grand opening, Levy's chartered 30 streetcars to bring eager shoppers to the new establishment. Levy's was then the largest store of its kind between Baltimore and New Orleans. (Cordray-Foltz Collection #1360, Box 10, Folder 3, Item 12.)

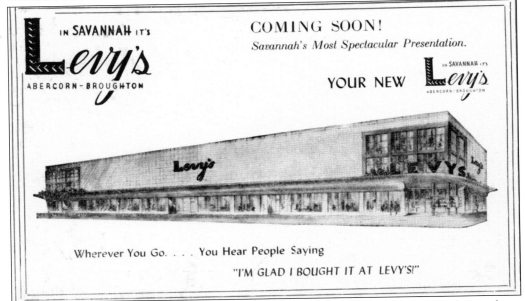

This advertisement shows the expanded and remodeled Levy's at Abercorn and Broughton Streets. The new block-long, three-story building opened to the public in 1950. Included in the new expansion was Savannah's first escalator, located in the center of the store, serving all three floors. This building was later the Maas Brothers Department Store and is now the Savannah College of Art and Design's Jen Library. (GHS Vertical File, Little Theater.)

The national department store chain of Sears, Roebuck and Company opened a Savannah store in 1930. Located at 310–318 West Broughton Street, the shop had an illuminated signboard and a large vertical projecting sign at the center of the upper stories. (Cordray-Foltz Collection #1360, Box 10, Folder 18, Item 7.)

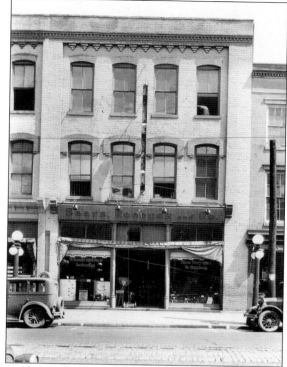

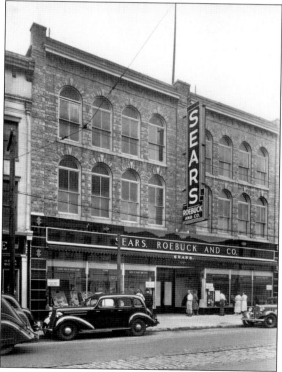

Sears expanded, opening this store at 217 West Broughton Street in 1939. Surrounding the plate glass windows of the storefront is an elaborate veneer of pigmented structural glass. The two-story vertical sign shows the Art Deco influence of the 1930s, and its lettering is traced in neon tubing. (Cordray-Foltz Collection #1360, Box 10, Folder 15, Item 15.)

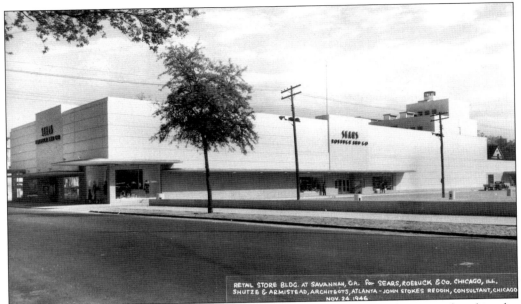

Sears closed its Broughton Street location and constructed a new retail store and parking lot occupying the two blocks bound by Duffy, Bull, Henry, and Drayton Streets. The building opened in 1946 and boasted air conditioning and wall murals depicting Georgia history. (Cordray-Foltz Collection #1360, Box 11, Folder 1, Item 23.)

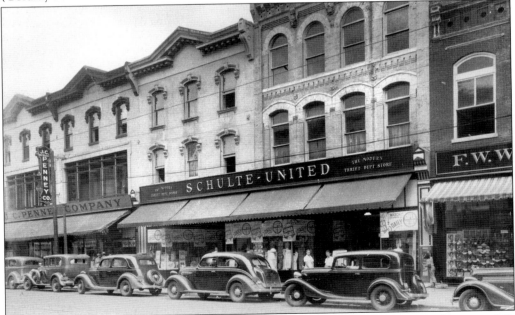

In the 1930s the south side of the 100 block of West Broughton Street was home to J.C. Penney, Schulte-United, and F.W. Woolworth. Schulte-United opened in 1929 as Savannah's first junior department store. Fascia boards with gilded lettering were common during the early decades of the 20th century. The J.C. Penney store began operation in 1934. (Cordray-Foltz Collection #1360, Box 10, Folder 12, Item 14.)

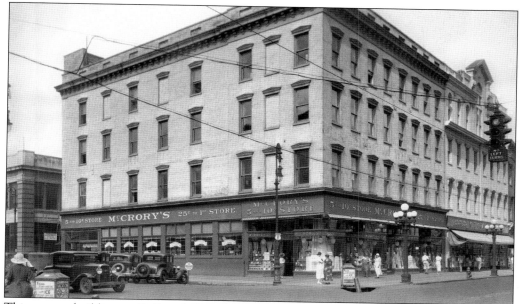

This corner building at Bull and Broughton Streets became home to McCrory's 5 and 10¢ Store in 1925. F.W. Woolworth pioneered the five-and-dime store concept in the 1870s. The success of Woolworth prompted others like J.G. McCrory and Samuel H. Kress to create their own chains. The photograph below shows McCrory's and its neighboring buildings after suffering 1960s remodeling. Windows were minimized, metal awnings were installed, and the gilded signboards were removed and replaced with large applied lettering. McCrory's closed this downtown location in 1991 after a fire. The building has undergone a restoration, and the Bull and Broughton façades now closely resemble their early 20th-century appearances. (Above: Cordray-Foltz Collection #1360, Box 10, Folder 6, Item 13; Below: Historic Savannah Foundation.)

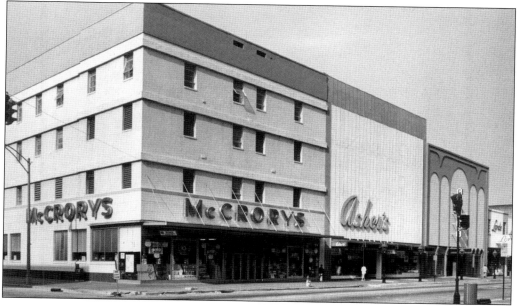

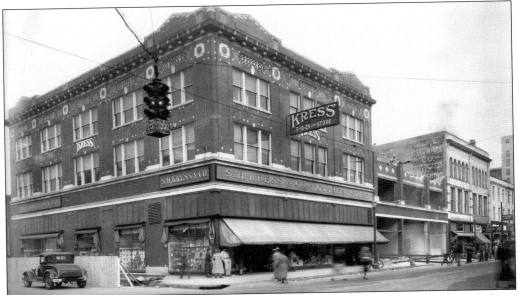

The above picture is of the original Kress at the northeast corner of Barnard and Broughton Streets. The five-and-dime store opened in 1923. The architectural distinction of the Savannah store reveals the Kress Company's desire to bring outstanding design to Main Street America. The over 200 stores built by Kress between 1900 and 1950 set a new standard in commercial architecture. In 1937 Kress purchased and demolished the neighboring Blumberg Brothers' building to double the size of the Savannah store. The enlarged, renovated, and modernized store, as shown below, was completed in September 1938 after 18 months of construction. Kress stayed open until 1997 and was the last of Broughton Street's five-and-dime stores to close. (Above: Cordray-Foltz Collection #1360, Box 10, Folder 13, Item 5; Below: Cordray-Foltz Collection #1360, Box 10, Folder 13, Item 3.)

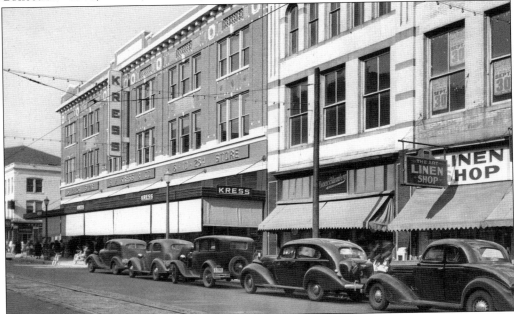

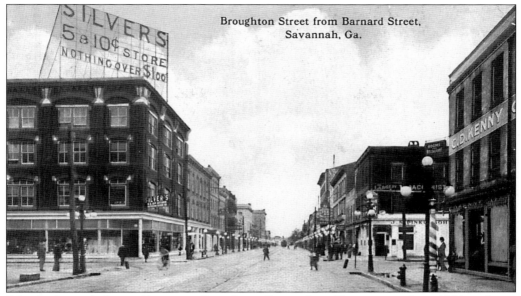

Silver's, located diagonally across Broughton Street from Kress, opened in 1904 and was another of Savannah's popular five-and-dime stores. Since Silver's predates Kress, this 1917 postcard shows the C.D. Kenny building in the location of the Kress store. Visible from blocks away was Silver's large rooftop sign. The letters of the sign were illuminated with hundreds of incandescent bulbs. (Author's collection.)

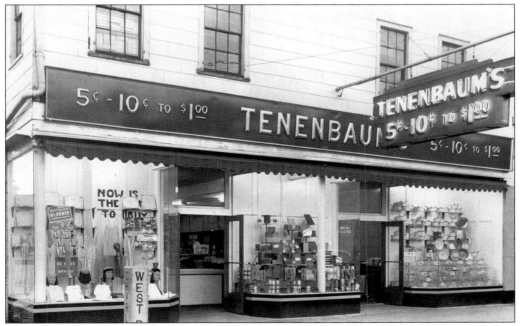

Tenenbaum's, at the corner of West Broad (now Martin Luther King Jr. Boulevard) and Charlton Streets, was owned and operated by Max Tenenbaum. George and Michael Tenenbaum worked at the family business as salesmen. (Cordray-Foltz Collection #1360, Box 9, Folder 20, Item 12.)

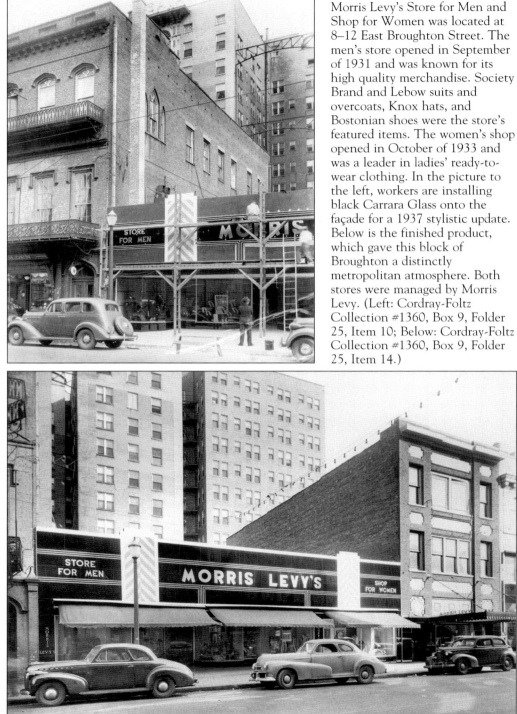

Morris Levy's Store for Men and Shop for Women was located at 8–12 East Broughton Street. The men's store opened in September of 1931 and was known for its high quality merchandise. Society Brand and Lebow suits and overcoats, Knox hats, and Bostonian shoes were the store's featured items. The women's shop opened in October of 1933 and was a leader in ladies' ready-to-wear clothing. In the picture to the left, workers are installing black Carrara Glass onto the façade for a 1937 stylistic update. Below is the finished product, which gave this block of Broughton a distinctly metropolitan atmosphere. Both stores were managed by Morris Levy. (Left: Cordray-Foltz Collection #1360, Box 9, Folder 25, Item 10; Below: Cordray-Foltz Collection #1360, Box 9, Folder 25, Item 14.)

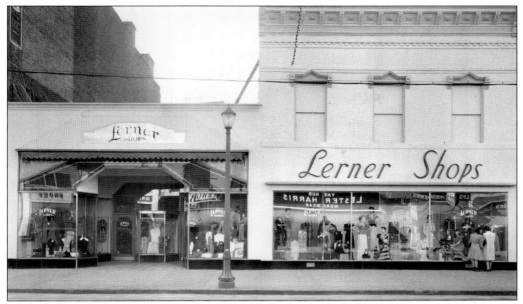

Above is a picture of the original Lerner Shops, which opened around 1930 at 17 West Broughton Street. In 1946 Lerner Shops purchased the building at the corner of Bull and Broughton Streets with plans to build a new ladies' and children's apparel store. Although the existing building was largely demolished, the original Savannah grey bricks were salvaged and reused as much as possible in the construction of the new store. Cletus W. Bergen, a well-known Savannah architect, designed the building to give a modern touch to one of Savannah's oldest business corners. The streamlined façade, cantilevered balcony, and plate-glass windows are illustrative of the modernist's desire to create a functional merchandising building. Lerner closed its downtown location in January of 1989. (Above: Cordray-Foltz Collection #1360, Box 10, Folder 9, Item 8; Below: GHS Photo Collection #1361 PH, Box 9, Folder 1, Item 1692.)

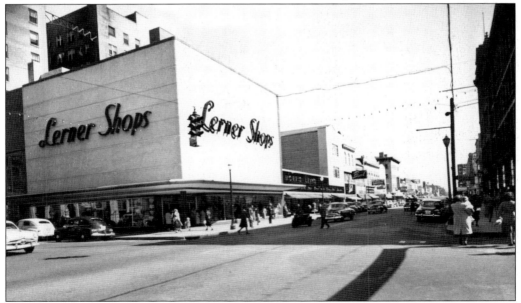

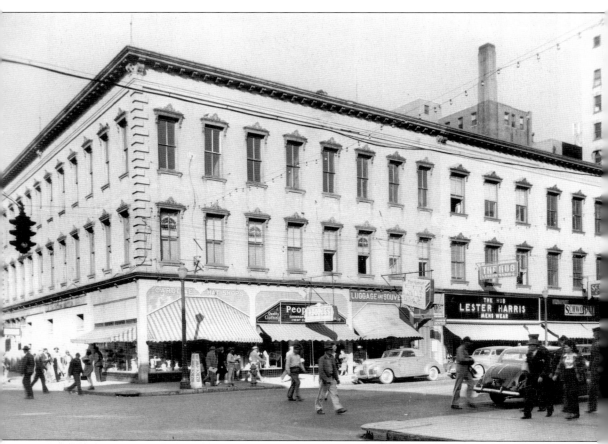

The Lyons Building, at the northeast corner of Whitaker and Broughton Streets, was home to The Hub, Moyle's, and Caroline Hat Shops. The Hub was established in 1896 and claimed to be Savannah's largest men's store in the 1930s. Lester Harris was president of the company during its most prosperous times. Moyle Trunk and Bag Company was Savannah's largest and oldest store specializing in luggage. Founded in 1880 by Edward Moyle, the shop was originally located across from Adler's Department Store on Broughton. Troy T. Rimes purchased Moyle's in 1920 but continued to operate the business under its original name. In addition to luggage, the firm carried a complete line of ladies' handbags, leather novelties, souvenirs, men's billfolds, and key cases. The company also repaired luggage and leather goods, specializing in zipper repair. (Cordray-Foltz Collection #1360, Box 10, Folder 10, Item 5.)

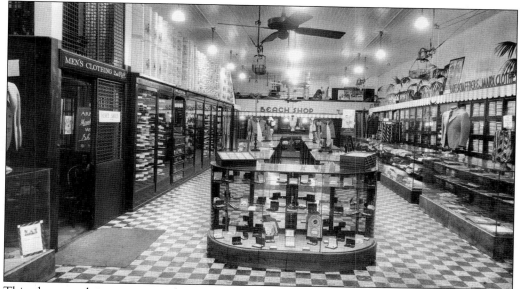

This photograph is an interior shot of The Hub's second floor. The store carried more than 50 nationally known brands of clothing, including Hart, Schaffner & Marx suits and overcoats; Dobbs and Mallory hats; and Manhattan shirts. The overhead baskets carried merchandise between the sales counters and a central wrapping area. (Cordray-Foltz Collection #1360, Box 10, Folder 10, Item 7.)

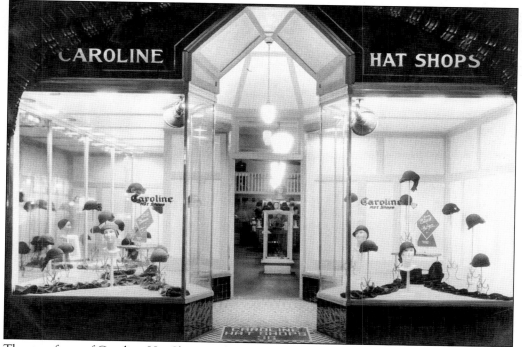

The storefront of Caroline Hat Shops took advantage of its corner location with extensive plate glass. Notice the octagonal entry foyer bordered by shop windows and the shop name in tile on the floor. (Cordray-Foltz Collection #1360, Box 10, Folder 10, Item 9.)

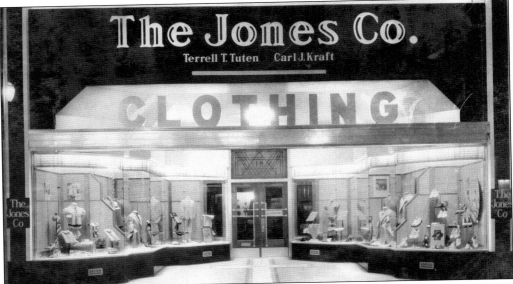

The Jones Company, established in 1921, was located at 18 East Broughton Street. In 1937, under the direction of Pres. Terrell T. Tuten and Vice Pres. Carl J. Kraft, the store underwent extensive remodeling. The result was an exceptionally modern storefront, complete with freestanding, backlit aluminum letters. The men's and boys' store was known as "Savannah's Own," and the business prided itself on its individual personality and personal attention to each transaction. (Cordray-Foltz Collection #1360, Box 9, Folder 26, Item 16.)

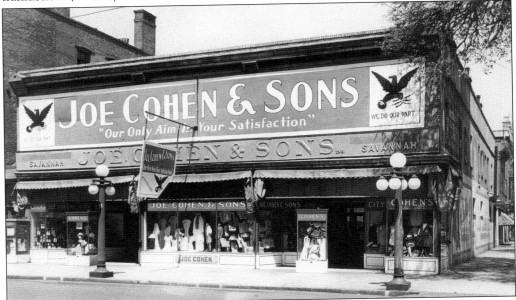

The clothing store of Joe Cohen and Sons, 402–406 West Broughton Street, opened around 1907. In this family business Joe Cohen was president, Louis A. Cohen was secretary, William Cohen was assistant secretary, and Samuel A. Cohen was the shop's tailor. To maximize exposure, the Cohens covered the second story of the front façade with signboards. (Cordray-Foltz Collection #1360, Box 10, Folder 19, Item 6.)

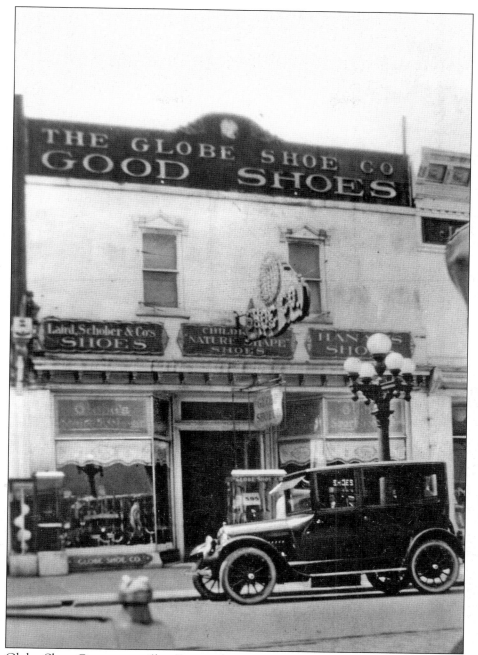

The Globe Shoe Company, still a Savannah institution, was established on November 18, 1892. The business's first building was at 22 West Broughton Street. This c. 1920s photograph is of Globe's second location at 17 West Broughton Street. The unique projecting sign was lit with incandescent bulbs and consisted of a globe and the words "Shoe Co." The reputation of the company was built upon its motto: "No one ever regretted buying Globe quality shoes." Rapid growth during the 1920s allowed the construction of the present three-story store at 19 East Broughton Street in 1929. (Cordray-Foltz Collection #1360, Box 9, Folder 26, Item 4.)

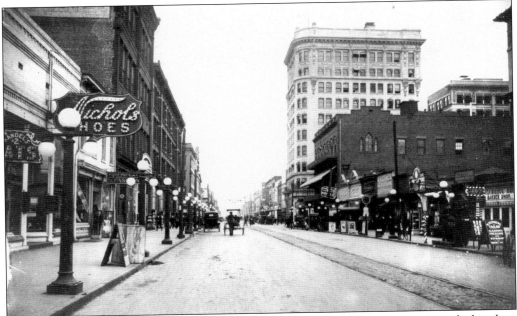

The 19 East Broughton Street store, erected by Globe Shoe Company in 1929, took the place of Nichols Shoes as shown above. The Globe building, although slightly modified from its original appearance, survives as an outstanding example of Art Deco design. All three floors were originally devoted to the retailing of women's, men's, and children's footwear. In the 1940s the Globe advertised that its "stock of merchandise was one of the most complete in the South, and the customers are counted not only in Savannah and the Coastal Empire territory but in far distant states, even foreign countries." (Above: GHS Photo Collection #1361 PH, Box 9, Folder 1, Item 1689; Below: Cordray-Foltz Collection #1360, Box 9, Folder 23, Item 6.)

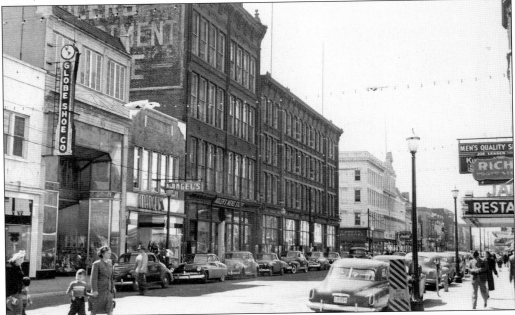

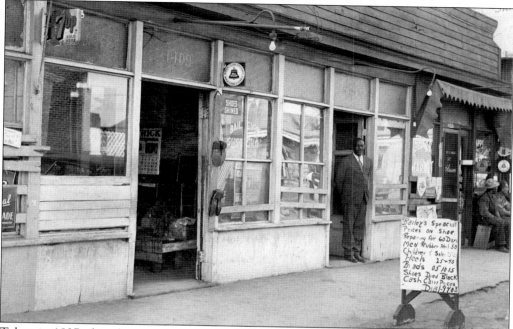

Taken in 1937, this photograph is of Reverend Bailey's Shoe Shop at 1409 East Broad Street. The sidewalk sign advertises shoe repairing and dyeing. (Cordray-Foltz Collection #1360, Box 9, Folder 17, Item 3A.)

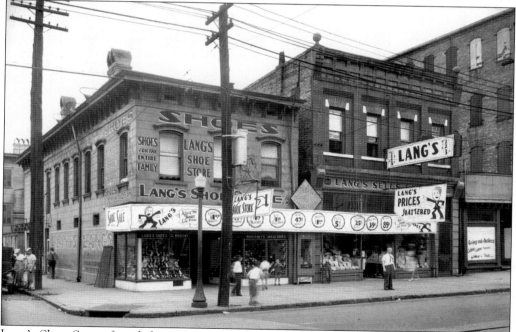

Lang's Shoe Store, founded in 1919, was located at 221–225 West Broad Street. With the slogan "Where Thrifty Families Shop and Save," Lang's offered men's, women's, and children's shoes at conservative prices. (Cordray-Foltz Collection #1360, Box 9, Folder 19, Item 12.)

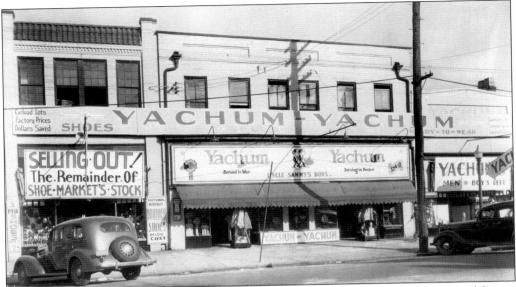

Yachum & Yachum, a shoe and ready-to-wear department store at 324–328 West Broad Street, was owned by the Perlman family. Morris and Hymie Perlman first opened the business as Perlman Brothers before World War I. After they returned from fighting in the war, the Perlmans reopened the store as Yachum & Yachum. The buildings were destroyed during a wave of sporadic violence following the assassination of Martin Luther King Jr. (Cordray-Foltz Collection #1360, Box 9, Folder 20, Item 10.)

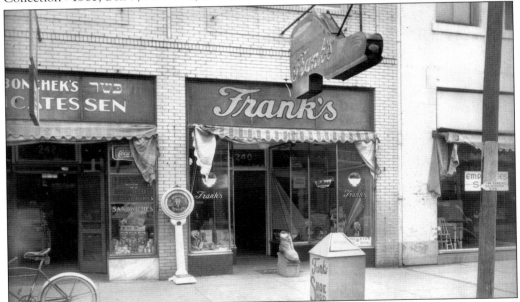

With its shoe-shaped neon sign, the specialty of Frank's was no mystery to Savannahians. Frank's Shoe Repair Shop advertised the best repair equipment in the city and the most efficient service. Frank A. Dilworth, manager of the shop, had worked in the shoe repair business since 1896. This 1938 photograph shows the business at its 240 West Broughton Street location. (Cordray-Foltz Collection #1360, Box 10, Folder 16, Item 1.)

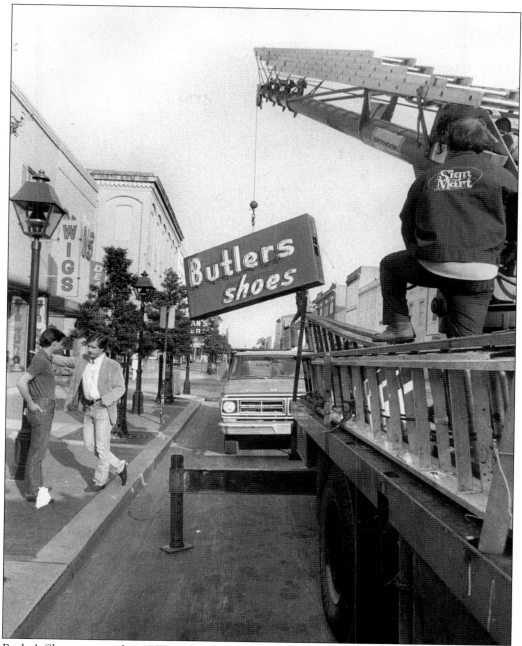

Butler's Shoes operated at 19 West Broughton Street from 1950 to 1986. This image documented the installation or removal of the store's neon sign. (Historic Savannah Foundation.)

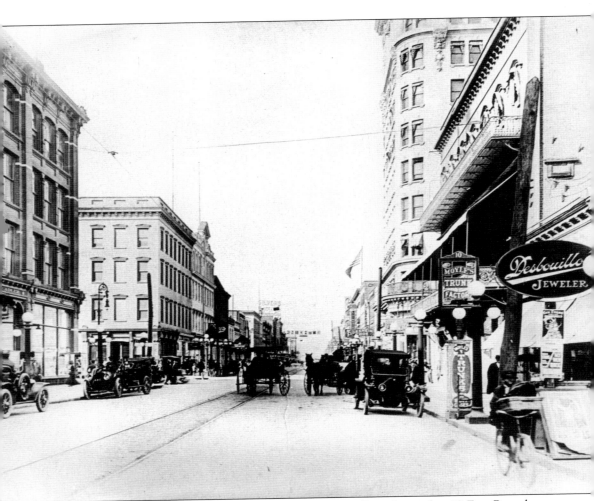

In the right foreground is a round wooden sign for Desbouillons, located at 12 East Broughton Street. The jewelry store was started by Aristides Louis Desbouillons as a watch shop in 1868. The company prided itself on furnishing the silverware, rare china, and fine jewelry that over the years became Savannah's heirlooms. Desbouillons later moved down the street to 126 East Broughton Street. This shop stayed open until 1974. (GHS Photo Collection #1361 PH, Box 9, Folder 1, Item 1714.)

Aaron Levy, a Russian immigrant, moved to Savannah and opened A. Levy & Son in 1900. The watch repair shop was across from the City Market at 211 West Congress Street. A. Levy & Son expanded in 1911 by buying out E. Figuris, an eyeglass and jewelry shop at 20 East Broughton Street, and moving to that location. In 1923 the business moved to the shop pictured above at the southwest corner of Drayton and Broughton Streets. The photograph below is of the southeast corner of the same intersection. Located on the site was Tash Rovolis Confectionery. The property was purchased and demolished for the construction of A. Levy & Son's new store. The company was renamed Levy Jewelers at this time. (Above: Cordray-Foltz Collection #1360, Box 9, Folder 27, Item 2; Below: GHS Photo Collection #1361 PH, Box 9, Folder 1, Item 1700.)

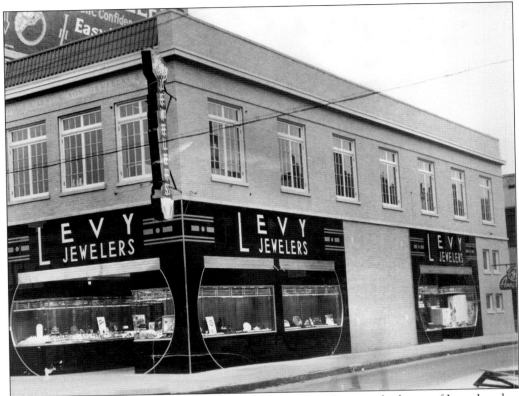

This "ultra-modern" building at 101 East Broughton Street became the home of Levy Jewelers in 1938. A decorative veneer of colored structural glass surrounded the storefronts. The upper floor was gray brick trimmed in cut stone. A corner neon sign advertised to pedestrians and motorists passing on either street. Beside the Drayton Street entrance was another neon sign promoting the store's GE appliances. A special feature of Levy Jewelers was its optical department, which conducted 21-point examinations. The building's current appearance is the result of a 1993 remodeling. Levy Jewelers' continual investment in their downtown store contributed to the revival of Broughton Street by inspiring neighboring business owners to invest in their own properties. (Savannah Jewish Archives, JVM036, Folder 1, Item 2.)

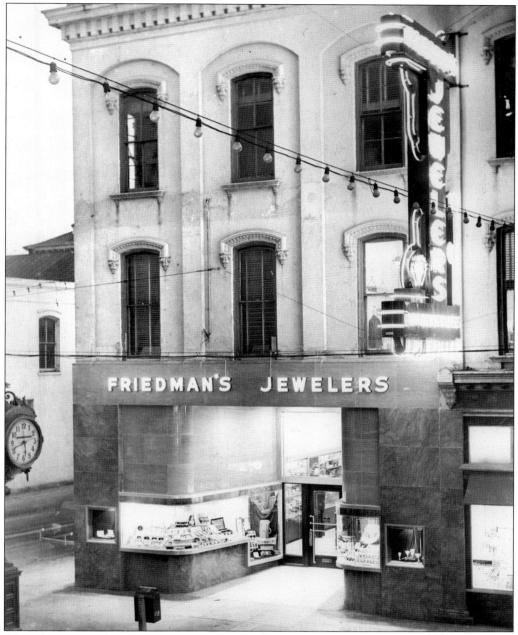

Above is a 1946 photograph of Friedman's Jewelers at 101 West Broughton Street. Benjamin Friedman founded the Savannah jewelry company in 1920. When Friedman's Jewelers acquired this building, the company modernized the façade with a polished stone veneer, recessed entry, and two-story neon sign. Although jewelry and watches were the company's specialties, Friedman's was also Savannah's distributor for American Bosch Radios. In the early 1990s Friedman's grew into the nation's third largest specialty retailer. By 2002 the company had 4,400 employees working in 651 stores in 20 states. Friedman's no longer has a downtown Savannah retail store. (Cordray-Foltz Collection #1360, Box 10, Folder 11, Item 9.)

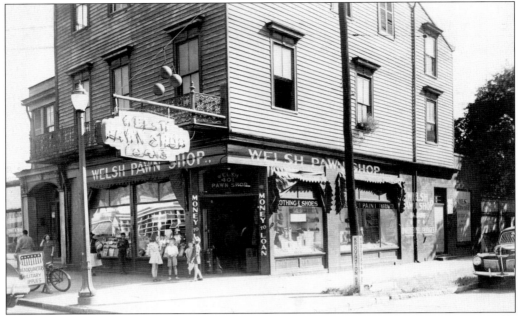

Welsh Pawn Shop was once located at the corner of Broughton and Habersham Streets. Locally owned and operated since 1913, Welsh Pawn continues to operate shops throughout Savannah. The three balls symbolizing the pawnbroker are derived from the coat of arms of the Medici banking family. In the 1990s the store building was transformed into a residence. (Cordray-Foltz Collection #1360, Box 10, Folder 5, Item 3.)

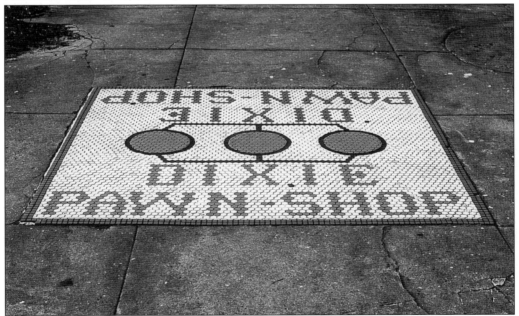

The only reminder of the Dixie Pawn Shop (demolished) is this tile sidewalk sign on the 300 block of East Broughton Street. The site is now a parking lot, and the Kennedy building, a former pharmacy, is the sole survivor on the block. (Photograph by the author.)

Two

HOME GOODS
AND HARDWARE

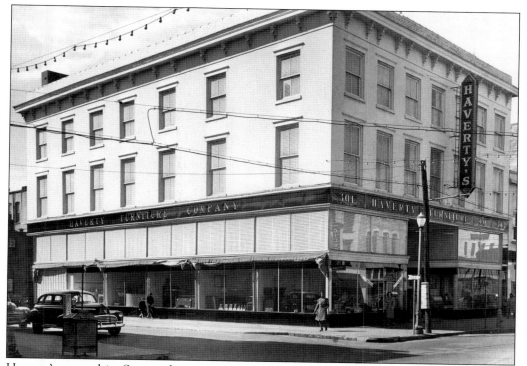

Haverty's opened its Savannah store in 1900 after the firm started in Atlanta in 1885. First located at 209 West Broughton Street, Haverty's subsequently moved to 301 West Broughton Street, the location pictured above. One of the big impetuses to business in the early part of the century was its Victrola and record department. Along with the furniture, these machines did a flourishing business. (Cordray-Foltz Collection #1360, Box 10, Folder 17, Item 13.)

Walker-Mulligan FURNITURE COMPANY

GA. TELEPHONE 462.
BELL TELEPHONE 1194.

FURNITURE, FLOOR COVERINGS,
STOVES AND
HOUSE FURNISHINGS.

ASSOCIATE HOUSES:
W. T. WALKER FURNITURE CO.
WASHINGTON, D.C.
WALKER-RHUDY FURNITURE CO.
ATLANTA, GA.
WALKER-MULLIGAN FURNITURE CO.
WAYCROSS, GA.
WALKER-MULLIGAN FURNITURE CO.
DURHAM, N.C.

N. W. COR. BROUGHTON AND JEFFERSON STREETS.

Savannah, Ga. _____ 190_

Sold to _____

Terms: _____

The 1907 invoice for a table and four chairs from the Walker-Mulligan Furniture Company includes an engraving of the shop building. The store was stocked with furniture, floor coverings, stoves, and house furnishings. Notice the bands of advertising that run between the windows of each story. This method of signage was common practice from the late 19th to early 20th century. Below is a 1939 photograph of the same building at the northwest corner of Broughton and Jefferson Streets. Maxwell Brothers and Asbill updated the building with an Art Deco façade. Also a furniture store, the company carried Karpen living room suites, Simmons mattresses and springs, Duo-Thurm oil circulators, Frigidaires, and Philco and Zenith radios. (Above: GHS Vertical File, Savannah Business Enterprises; Below: Cordray-Foltz Collection #1360, Box 10, Folder 18, Item 2.)

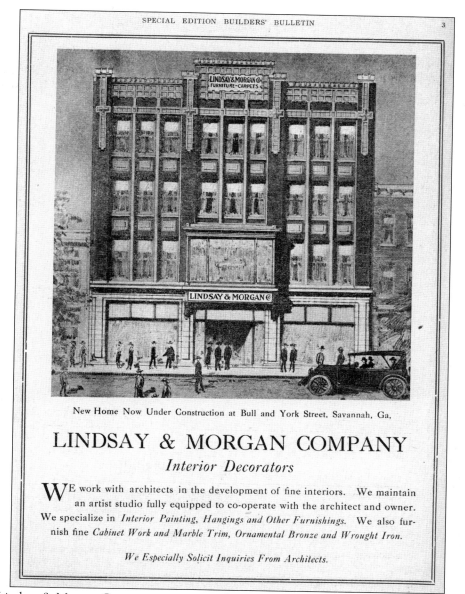

New Home Now Under Construction at Bull and York Street, Savannah, Ga.

LINDSAY & MORGAN COMPANY

Interior Decorators

WE work with architects in the development of fine interiors. We maintain an artist studio fully equipped to co-operate with the architect and owner. We specialize in *Interior Painting, Hangings and Other Furnishings.* We also furnish fine *Cabinet Work and Marble Trim, Ornamental Bronze and Wrought Iron.*

We Especially Solicit Inquiries From Architects.

The Lindsay & Morgan Company can trace its beginnings to 1866. At that time James Lindsay was operating a furniture store in a loft on the north side of Broughton Street between Jefferson and Montgomery. When Lindsay died in 1870, his two sons, Gilbert and W.J., took over the business. David B. Morgan bought into the business in 1885, and the firm became Lindsay & Morgan. The store moved several times before the construction of the York Street building. The building at Bull and York Streets illustrated in this advertisement was completed for the Lindsay & Morgan Company in 1921. A prominent feature is the projecting second-story bay window used to showcase the store's fine furniture. In addition to carrying a full line of furniture and carpets, Lindsay & Morgan offered interior design services. In fact, architect Claude K. Howell and theater owner Arthur Lucas employed the company in 1921 to design the draperies for the Lucas Theatre. (GHS Vertical File, Savannah Business Enterprises.)

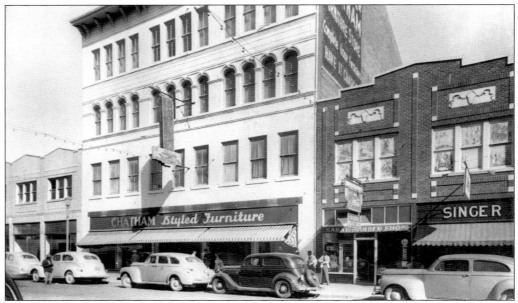

Chatham Styled Furniture, located at 230 West Broughton Street, was one of the largest home furnishing establishments in the Southeast. The company took advantage of the building's height, painting an advertisement on the east wall that was visible blocks away. Gutted by fire in 1989, this building was demolished in 1991. (Cordray-Foltz Collection #1360, Box 10, Folder 16, Item 6.)

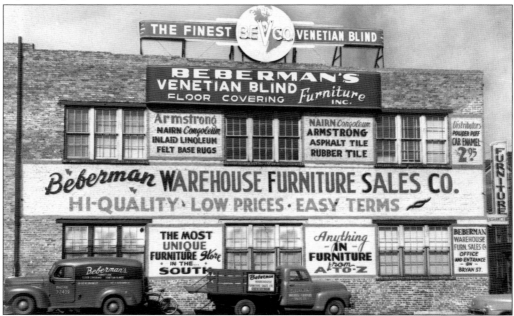

Beberman Warehouse Furniture Sales Company, 511–512 West Bryan Street, used almost every inch of its façade for advertising. With "high quality, low prices, and easy terms," "the most unique furniture store in the South" carried "anything in furniture from A to Z." (Cordray-Foltz Collection #1360, Box 10, Folder 21, Item 4.)

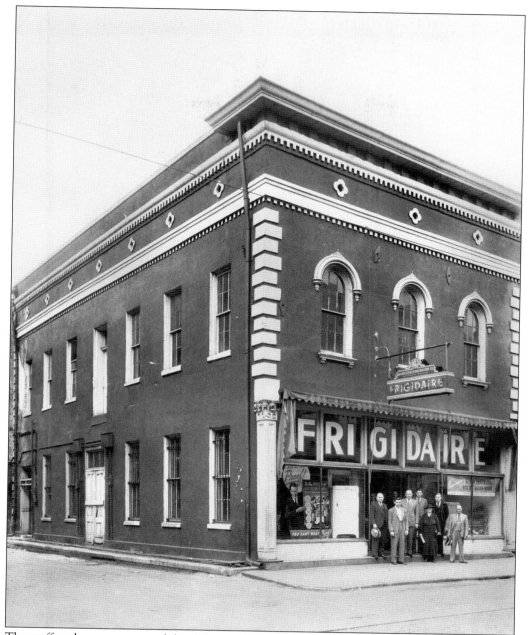

The staff and management of the Advanced Refrigeration Company posed at the entrance of their 37 Whitaker Street store for this 1936 photograph. The company was an authorized dealer for Frigidaire. (Cordray-Foltz Collection #1360, Box 13, Folder 17, Item 15.)

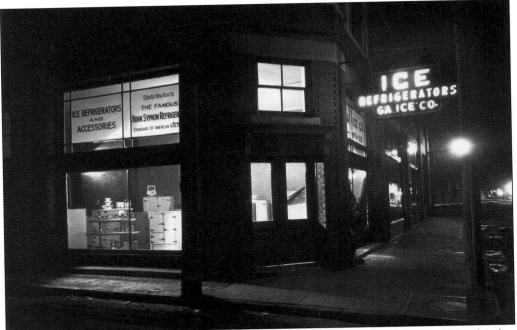

The Georgia Ice Company, established in 1920, operated the above retail shop at 144 Whitaker Street. The shop displayed and sold the latest in ice refrigerators, like the Coolerator shown below. The manufacturing plant for the Georgia Ice Company was located on Harmon Road and produced 250 tons of ice daily. In addition to its daily output, a reserve of 10,000 blocks of ice was kept in storage for the summer months. (Above: Cordray-Foltz Collection #1360, Box 6, Folder 6, Item 8; Below: Cordray-Foltz Collection #1360, Box 6, Folder 6, Item 9.)

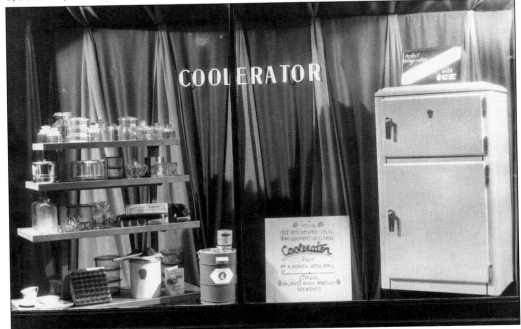

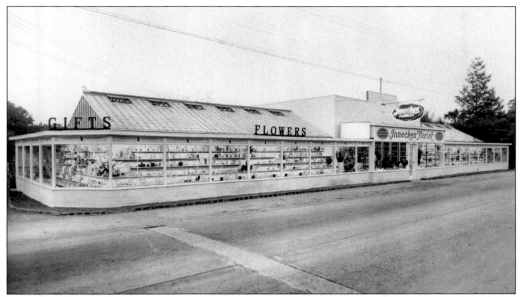

The Innecken family started their floral business in 1926. The 1500 Wheaton Street shop was designed to take advantage of its long street frontage. A façade of plate glass enclosed a narrow retail space that wrapped around the building's core of greenhouses. Located next to Hillcrest Cemetery, this building was demolished for the Truman Parkway. (Cordray-Foltz Collection #1360, Box 13, Folder 15, Item 11.)

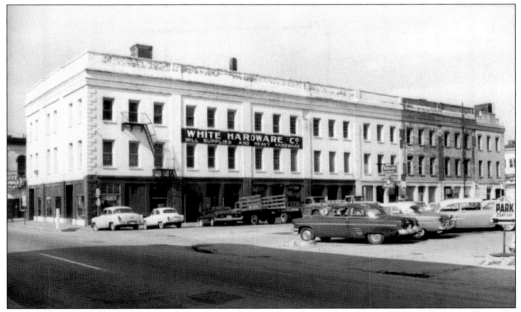

John F. White established the White Hardware Company in 1911. The wholesale and retail hardware and supply firm moved to the Gibbons Block in 1930, occupying four of the row's eight shops. The Gibbons Block on St. Julian Street was built for lawyer and Savannah mayor Thomas Gibbons in 1820. The Allen family bought White Hardware in 1974 and operated the business until early 1990. This row is now bars and restaurants. (Historic Savannah Foundation.)

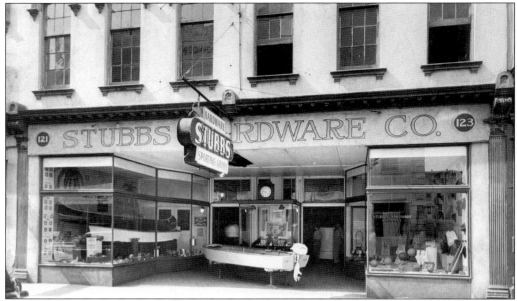

Brothers Otis and J. Marcus Stubbs formed Stubbs Hardware Company in 1923. The shop operated at 121–123 West Congress Street. An ardent fisherman and promoter of athletics, Otis Stubbs carried an extensive line of sporting goods at his hardware shop. Stubbs sponsored baseball, basketball, football, bowling, and other teams and promoted numerous competitive events. (Cordray-Foltz Collection #1360, Box 11, Folder 10, Item 1.)

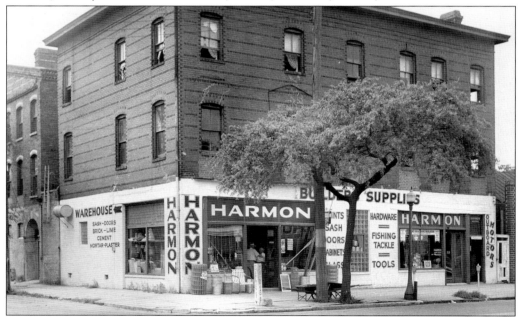

The building supply firm of Burns and Harmon was established in 1914 on the 300 block of West Broad Street. By the late 1930s the company was renamed John M. Harmon and Son. In addition to the complete line of building materials, Harmon operated a repair department for window sashes, doors, and screens. (Cordray-Foltz Collection #1360, Box 9, Folder 20, Item 11.)

The Neal-Blun Company, a distributor of quality building materials with a warehouse at 12–20 West Bay Street, shows up in this 1910 postcard. Savannah grew rapidly during the first half of the 20th century, and the company's service during this period of expansion made it one of the most respectable building suppliers in Savannah. Established in 1897, Neal-Blun stayed in operation until 1991. During its later years, the company operated out of an early–20th century warehouse on Montgomery and 50th Streets. (Author's collection.)

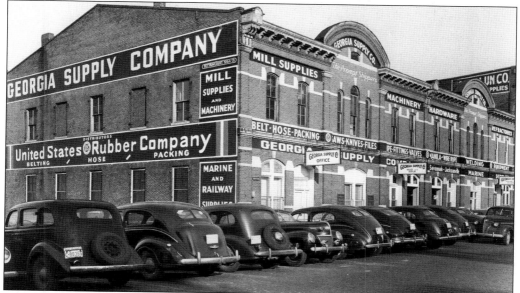

Next door to Neal-Blun was the Georgia Supply Company. The Savannah-based business began in 1901 and opened a Jacksonville branch in 1905. As the warehouse's façade on West Bay Street advertised, the company carried mill supplies and machinery. Along with the Neal-Blun warehouse, the Georgia Supply building was demolished to make way for the Hyatt Hotel. (Cordray-Foltz Collection #1360, Box 6, Folder 7, Item 7.)

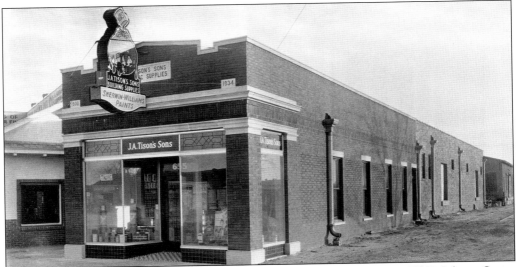

Established in 1900, J.A. Tison's Sons Building Supplies erected a shop at 655 E. Liberty Street in 1934. In return for the store carrying their brand, Sherwin-Williams Paints supplied J.A. Tison's Sons with their signature sign. The "Cover the Earth" logo consisted of red paint pouring over the planet from a can with the letters *SWP*. Legend has it that this logo became controversial during the 1950s red scare. Coupled with the image of red covering the globe was the suspicion that SWP stood for the Socialist Workers Party. (Cordray-Foltz Collection #1360, Box 12, Folder 11, Item 10.)

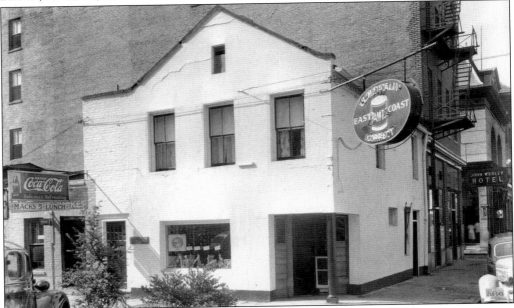

In the 1930s East Coast Paint Company's retail shop was at the corner of Drayton and St. Julian Streets. J. Henry Allen, president and founder of the company, claimed that his paints were "climatically correct." He contended that the paints made by East Coast were chemically engineered for the Savannah climate. (Cordray-Foltz Collection #1360, Box 13, Folder 1, Item 1.)

Three
TRADES AND SERVICES

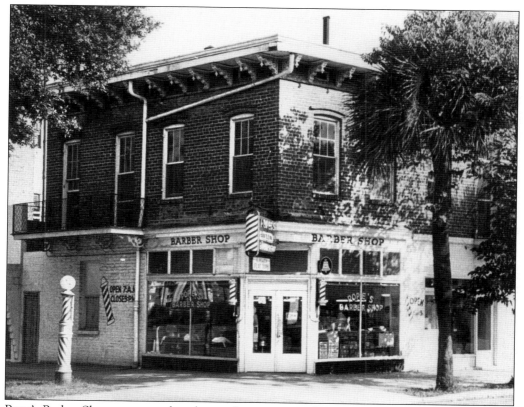

Pope's Barber Shop once stood at the southeast corner of Montgomery Street and Oglethorpe Avenue. The red-and-white striped pole has been used for centuries to mark the location of a barber. During medieval times, the barber was also the surgeon, or blood letter. The red stripes denoted the blood; the white, the barber's bandage. (Historic Savannah Foundation.)

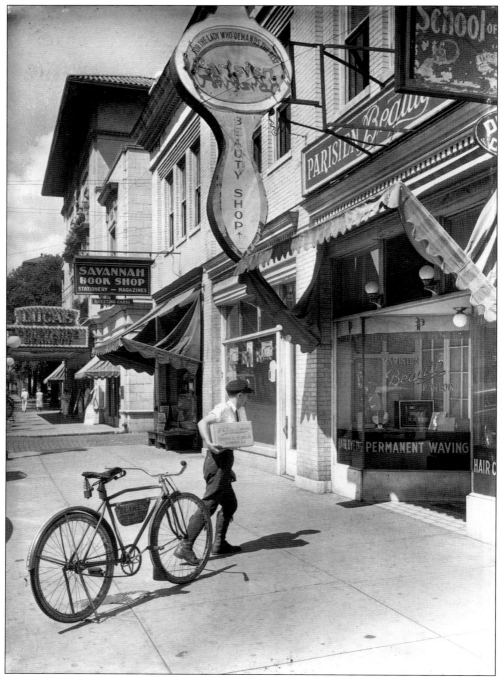

Just down Abercorn Street from the Lucas Theatre was the Parisien Beauty Parlor. The wonderful neon sign in the shape of a hand mirror carried the name of the shop and its motto: "For the lady who demands the best." Gold-leaf signs on the shop windows advertised hair dyeing, permanent waving, and hair cutting. (Cordray-Foltz Collection #1360, Box 9, Folder 1, Item 2.)

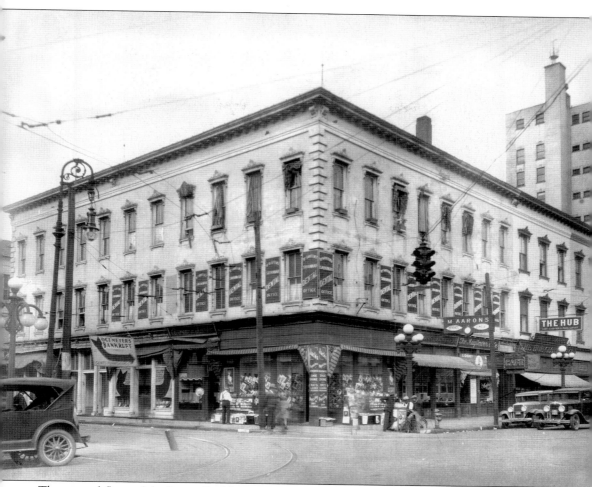

The second floor of the Lyons Building, at the corner of Broughton and Whitaker Streets, was the dental office of Dr. Griffin from 1912 to the mid-1940s. The dentist made sure his presence was known by mounting signboards between every window of his office. Octavus A. Meyer's furnishings for men, Jack's newsstand, M. Aaron's jewelry, the Mayflower Café, and the Hub clothing store occupied the first floor at this time. (Cordray-Foltz Collection #1360, Box 10, Folder 10, Item 3.)

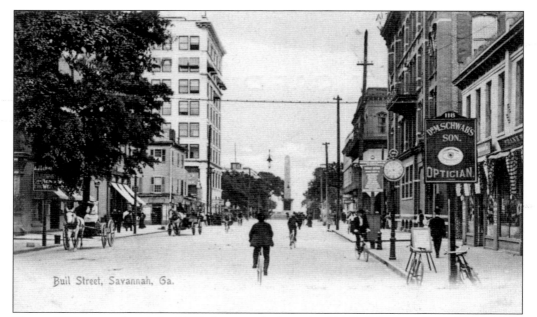

The *c.* 1903 postcard and the 1937 photograph show the 118 Bull Street office of optometrist Dr. I.M. Schwab. Founded in 1888, the business began with Dr. Schwab and his father in a building on the west side of Bull Street near Broughton Street where the former Liberty National Bank Building sat. The office moved to 118 Bull Street in 1903. Early signs like the one in the postcard often incorporated symbols to identify trades. Opticians used a pair of eyeglasses or an eye for their signs. As literacy improved, signs became more verbal. In the 1930s Schwab installed a neon sign with only text, consistent with popular advertising trends. (Above: Author's collection; Below: Cordray-Foltz Collection #1360, Box 10, Folder 23, Item 14.)

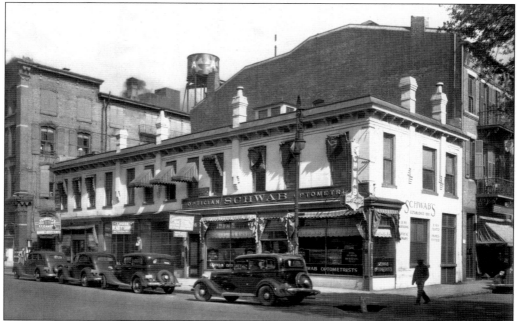

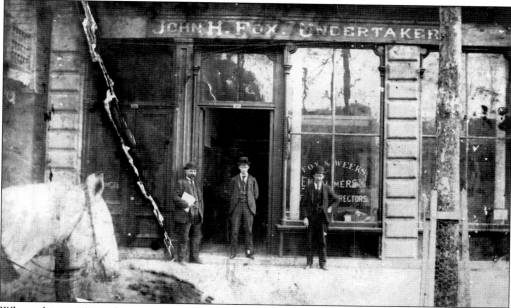

When this *c.* 1900 photograph was taken, Fox and Weeks, embalmers and funeral directors, operated out of 106 West Liberty Street. Still in business today, Fox and Weeks began providing funeral service in 1882. (Cordray-Foltz Collection #1360, Box 12, Folder 11, Item 15.)

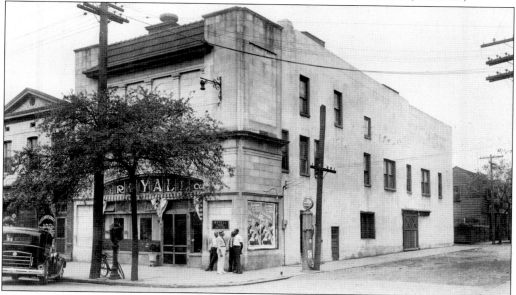

The Royall Company building at the corner of West Broad and Gaston Streets was demolished for the construction of Interstate 16 in the early 1960s. The undertaking business moved to this location in 1924. The building had been the old Globe Theater and was remodeled at a cost of $40,000. William H. Royall (1848–1905), founder of the company, was Savannah's first African American to open an undertaker business. He learned the trade during his employment with Henderson Brothers funeral directors. (Cordray-Foltz Collection #1360, Box 9, Folder 21, Item 4.)

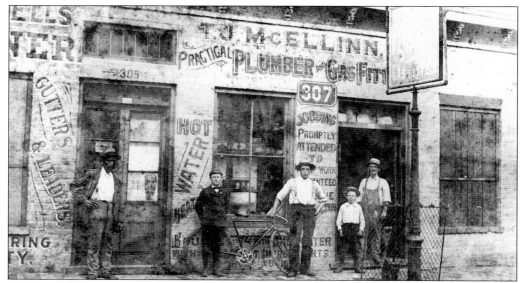

Thomas J. McEllinn started working as a plumber for the firm of P.H. Kiernan. In 1895 he opened his own shop near the corner of Whitaker and Liberty, calling himself a practical plumber and gas fitter. A city directory advertisement for his new shop read as follows: "Houses fitted with gas and water with all the latest improvements at short notice. Particular attention given to ventilation of waste and soil pipe. All work guaranteed." (GHS Photo Collection #1361 PH, Box 13, Folder 19, Item 2891.)

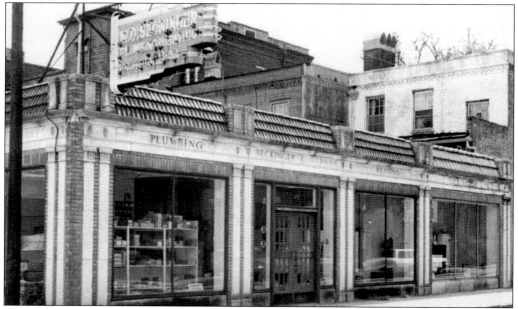

The plumbing and heating concern of Seckinger & Garwes erected this building at 412 Whitaker Street in 1928. This area of Whitaker was home to other commercial buildings, including the Harm Dairy and an automobile service station. Although the neon sign no longer survives, the lettering in the frieze still identifies the building's former use. (Historic Savannah Foundation.)

In the 1930s Bradley Lock and Key Shop was located at 108 East State Street. Of particular note is the gunsmith sign in the shape of a shotgun on the left side of the storefront. Simon Bradley, the founder of the business, came to Savannah from Providence, Rhode Island, in 1890. Before opening his own shop, Bradley worked in John Wohonka's locksmith shop on Congress Street near City Market. He was also employed as a conductor on the streetcar line to Isle of Hope. (Cordray-Foltz Collection #1360, Box 13, Folder 2, Item 3.)

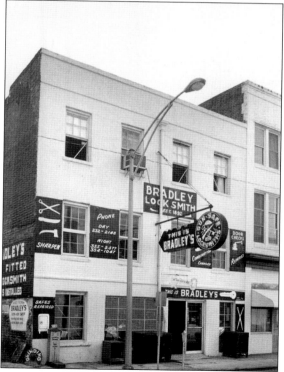

The Savannah institution, which claims to "sharpen anything but your wits" and "fix anything but a broken heart," moved to its present location at 24 East State Street in 1937. The wall paintings and the large, key-shaped metal sign, minus its neon tubing, still survive. The family business has served Savannahians for over 100 years. (Historic Savannah Foundation.)

49

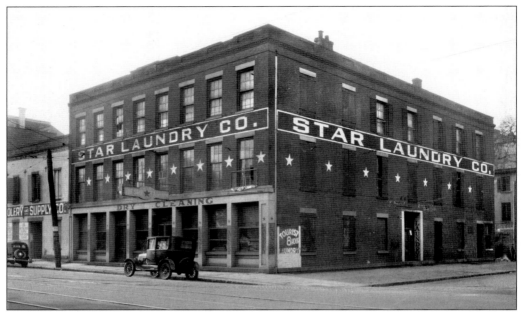

Adorned with its namesake, the plant of the Star Laundry Company (established 1915) was located at 121–123 West Bay Street. The laundry and dry-cleaning business promised a perfect job on all garments, using the most modern and scientific methods. They also offered rapid collection and delivery services. (Cordray-Foltz Collection #1360, Box 9, Folder 12, Item 7.)

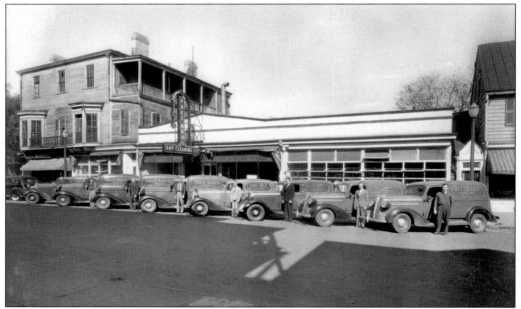

The staff of Free Brothers posed alongside the company's fleet of delivery trucks for this photograph. The large dry-cleaning and laundry business was located at 408 East Broughton Street. Founded in 1927, Free Brothers operated under the high standards set by its slogan: "Our cleaning art keeps wardrobes smart." (Cordray-Foltz Collection #1360, Box 10, Folder 5, Item 4.)

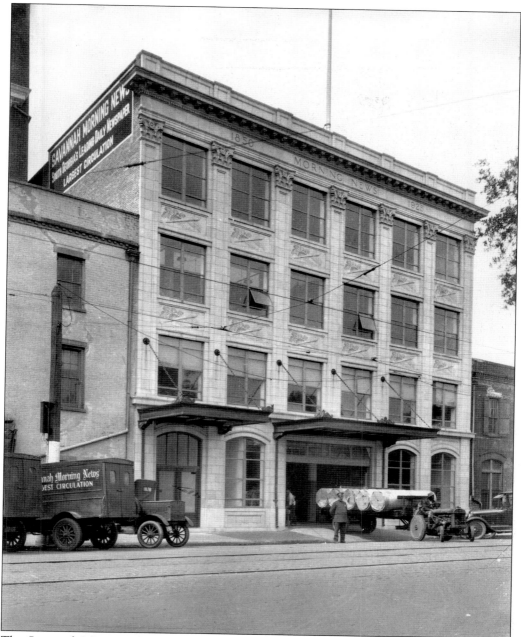

The *Savannah Morning News*, "South Georgia's leading daily newspaper," was first published January 15, 1850. The offices of the paper were located at the southwest corner of Whitaker and Bay Streets. This photograph shows the 1925 addition to the old, mansard-roofed building. In 1930–1931 the *Morning News* purchased the *Savannah Evening Press*, which began in 1891. Although the business and mechanical departments were jointly operated, the two papers' editorial departments engaged in spirited rivalry. One of the best known writers for the *Morning News* was Joel Chandler Harris, author of the "Uncle Remus" stories. (Cordray-Foltz Collection #1360, Box 13, Folder 16, Item 5.)

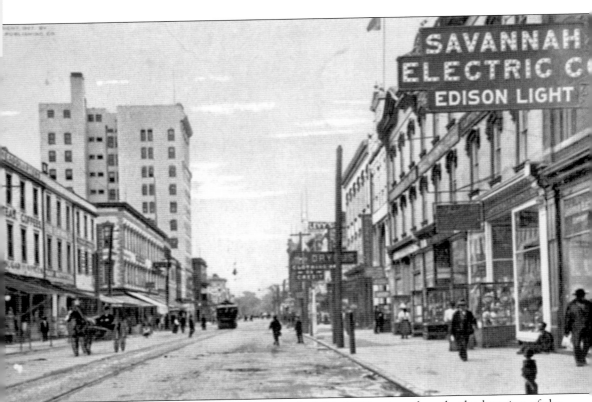

The incandescent bulb sign in the foreground of this 1908 postcard marks the location of the Savannah Electric Company's offices at 115–117 West Broughton Street. The Savannah Electric Company was incorporated in 1901 to own and operate power plants that supplied electricity for certain streetlights and railroads. In the early 1900s this company competed with others—like the Savannah Power Company, the Chatham County Traction Company, and the Savannah Lighting Company—to supply Savannah with electricity. (Author's collection.)

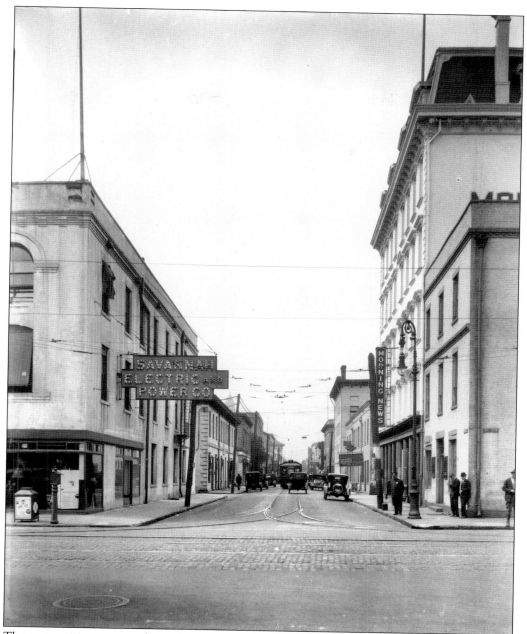

The competition among the early power suppliers was uneconomical, and each company was in constant financial trouble. Therefore, the Savannah Electric and Power Company was organized in 1921 to acquire the rights and assets of the Savannah Electric Company, the Savannah Power Company, and the Chatham County Traction Company. On June 27, 1923, it also acquired the Savannah Lighting Company. Offices were located at 25–27 West Bay Street, across Whitaker Street from the *Savannah Morning News*. For years the company's Riverside Plant at the foot of West Broad Street was the primary producer of electricity for Savannah. (Cordray-Foltz Collection #1360, Box 13, Folder 16, Item 1.)

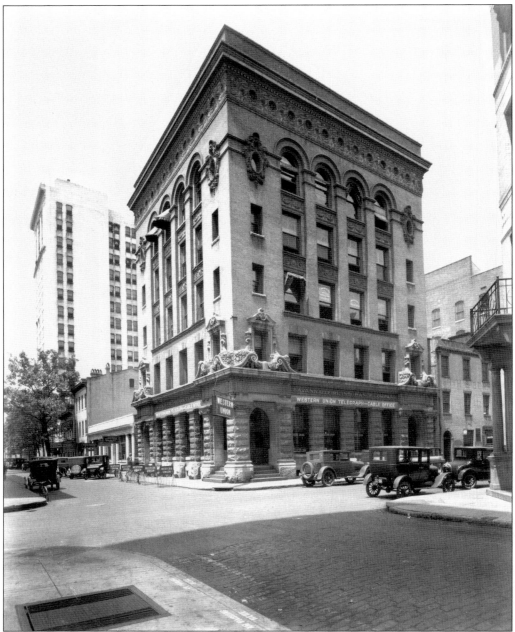

The Western Union Telegraph and Cable Office occupied the first floor of the Citizens Bank building at the corner of Drayton and Bryan Streets. Designed by G.L. Norrman, the building was completed in 1895–1896. The ornate stone carving was done by a Mr. Rackles. This craftsman had completed similar work for the Biltmore mansion in Asheville, North Carolina. (Cordray-Foltz Collection #1360, Box 6, Folder 11, Item 15.)

Four
FOOD MARKETS
AND MANUFACTURERS

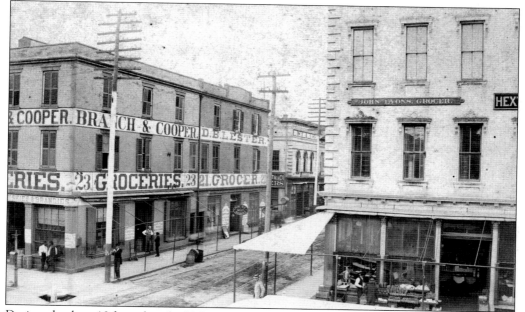

During the late 19th and early 20th centuries the intersection of Whitaker and Broughton Streets was home to several grocers. Branch & Cooper Groceries was located at the northwest corner, and John Lyons operated out of his building on the northeast corner. Just down Whitaker was D.B. Lester, which advertised "pure old malt whiskey" on a sidewalk signpost. (GHS Photo Collection #1361 PH, Box 13, Folder 19, Item 2892.)

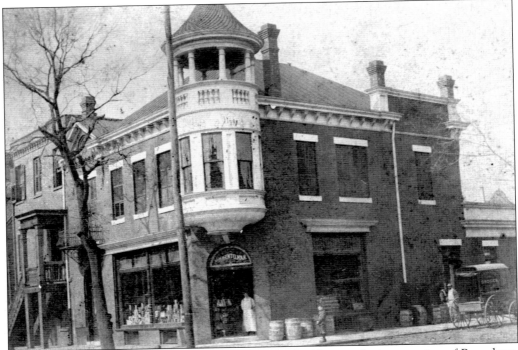

J.H.H. Entelman moved his corner grocery into this building at the intersection of Broughton and Price Streets in 1897. Visible in the arched transom over the entrance is the proprietor's name in stained glass. Before relocating to this building, Entelman's grocery was located further east down Broughton past East Broad Street. The store carried fine groceries, wines, liquors, and cigars. Notice the National Biscuit Company tins lining the front counter and the Sunshine Biscuit rack to the right of the shoppers. (Historic Savannah Foundation.)

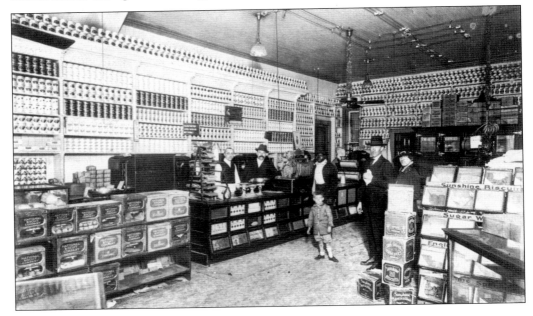

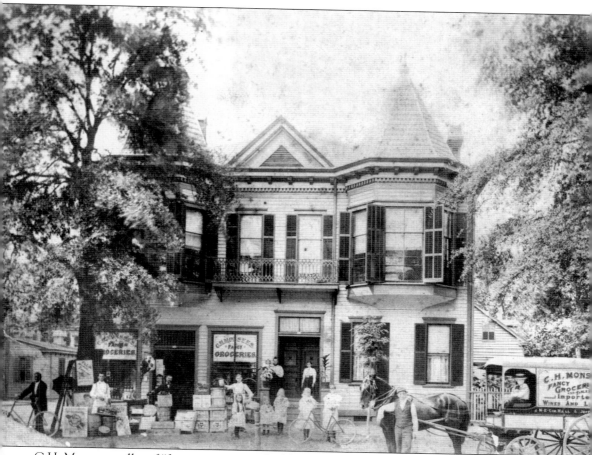

C.H. Monsees, seller of "fancy groceries and table delicacies," operated a grocery store out of his house (built 1905) at the northeast corner of Hall and Jefferson Streets. Monsees, a German immigrant, came to Savannah in 1872. In addition to opening a store, he invested in real estate, building apartment houses on land near his residence. (Historic Savannah Foundation.)

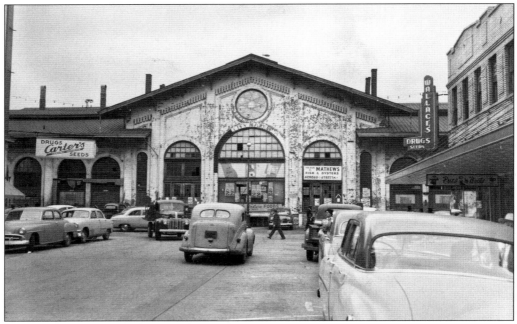

The above photograph shows the southern façade of the former City Market. Constructed in 1870 at a cost of $160,550, the City Market was designed by Martin P. Muller and Augustus Schwaab. This building was the last of a series of markets erected on the Ellis Square site since 1763. Developers demolished the City Market in 1954 and built the parking deck pictured below. The loss of this Italianate architectural treasure and the attempted demolition of the 1820 Davenport House led to the formation of the Historic Savannah Foundation in 1955. (Historic Savannah Foundation.)

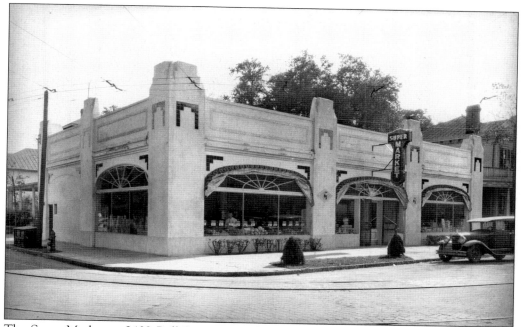

The Super Market at 2402 Bull Street opened around 1936. The store carried locally grown fruits and vegetables and leading national brands of canned and packaged foods. According to a 1938 newspaper advertisement, the Super Market "was recognized as one of the most modern food emporiums in this section of the state" and was "a model of grocery store construction and equipment." (Cordray-Foltz Collection #1360, Box 11, Folder 3, Item 8.)

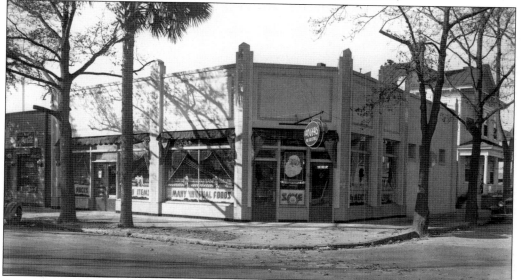

Rogers Stores, Inc., wholesale and retail grocers, was established in 1925. Warehouses for Rogers were located in the Central of Georgia yards, and the retail stores were scattered throughout the city. This corner store at the 2302 Bull Street opened in 1930. Although no longer occupied by Rogers, the building has been rehabilitated and houses a café and gift shop. (Cordray-Foltz Collection #1360, Box 11, Folder 3, Item 5.)

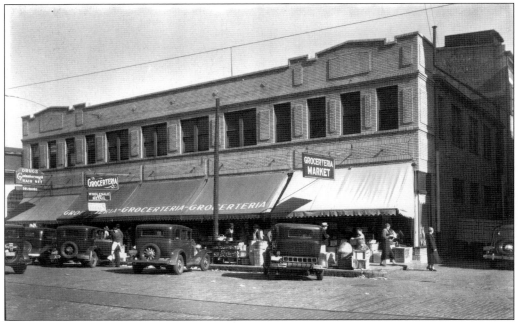

The Grocerteria opened at 32–38 Barnard Street in 1920. The store stocked all the well-known national brands, and its meat market was considered one of Savannah's finest. The fleet of trucks maintained by the Grocerteria supplied the store with a regular flow of fresh produce and other perishables. The company also stocked foods in its large refrigerated warehouse. Because of the store's everyday hustle and bustle, it became known as one of the busiest spots in town. (Above: Cordray-Foltz Collection #1360, Box 9, Folder 9, Item 5; Below: Cordray-Foltz Collection #1360, Box 9, Folder 9, Item 11.)

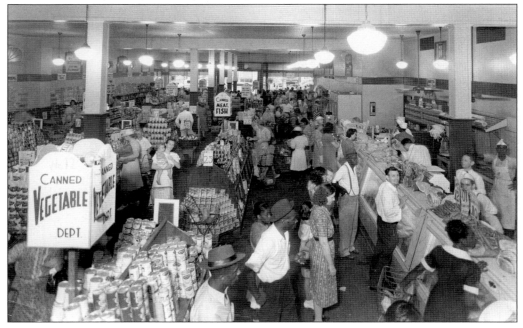

Mack Wilson posed in front of his confectionery at 408 West Hall Street for this 1946 photograph. Small food stores like this one were scattered throughout the neighborhoods south of the downtown core. In return for Wilson selling Holsum-Derst bread, the local bakery supplied him with a hanging sign. A specialty of the confectionery was Wilson's "bar-b-cue." (Cordray-Foltz Collection #1360, Box 12, Folder 4, Item 7.)

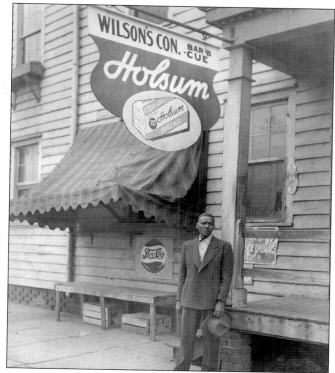

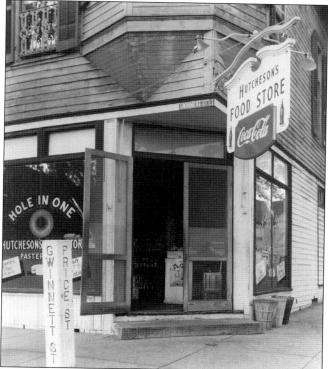

This photograph of Hutcheson's Food Store, located at the corner of Gwinnett and Price Streets, was taken in 1948. Pastries, especially "Hole in One" donuts, were Hutcheson's signature. The store's Coca-Cola sign was a standard signboard supplied by the bottling company. (Cordray-Foltz Collection #1360, Box 11, Folder 20, Item 1.)

61

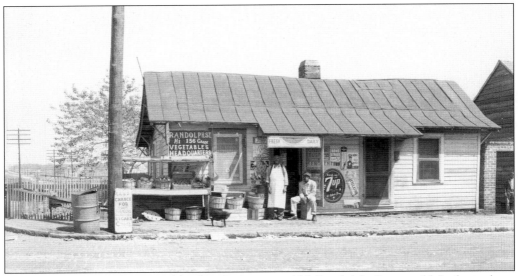

The humble Hi-Grade Vegetables Headquarters at 156 Randolph Street sold fresh produce, soda, and tobacco to passersby. Scattered around the doorway are tin signs for Philip Morris, Pepsi-Cola, and Bond Street Pipe Tobacco. (GHS Photo Collection #1361 PH, Box 13, Folder 4, Item 2688.)

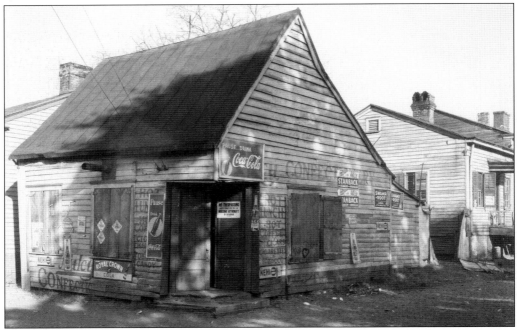

Layers of signage from different eras litter the clapboards of this structure, which once stood on Broughton Lane at Price Street. Tin signs for Coca-Cola, Royal Crown Cola, Nehi Root Beer, Stanback, and Swamp-Root obscure the confectionary's original painted signage. The "No Trespassing" sign posted on the door by the Housing Authority of Savannah was likely the building's final layer before demolition. (GHS Photo Collection #1361 PH, Box 13, Folder 3, Item 2679.)

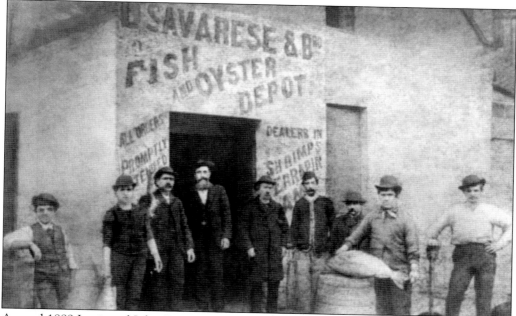

Around 1889 Louis and John Savarese established L. Savarese & Bro., Fish and Oyster Depot. According to the wall paintings on their shop, the business also sold shrimp and terrapin. (GHS Photo Collection #1361 PH, Box 20, Folder 5, Item 4040.)

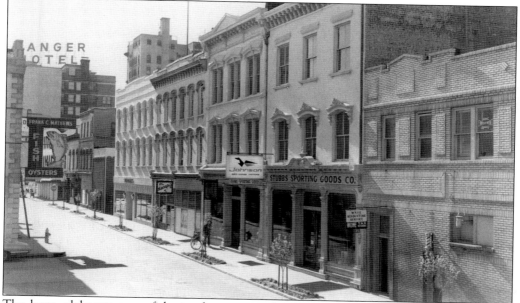

The large, elaborate neon fish sign hangs over the entrance to Frank C. Mathews fish and seafood store at 116 West Congress Street. Frank C. Mathews began his seafood business in the 1890s, originally dealing out of the City Market. Mathews moved the shop to 116 West Congress in the 1950s. A name once synonymous with Savannah seafood, Frank C. Mathews closed in 1995. The sign survives, restored with the title of another business. (Historic Savannah Foundation.)

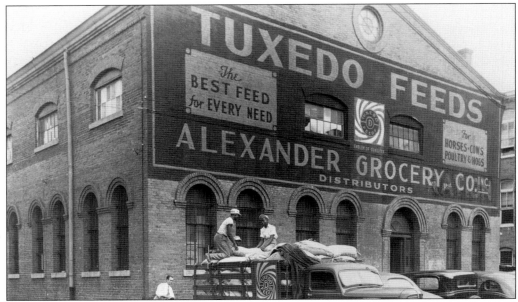

The Alexander Grocery Company was founded in 1892 by Henry R. Alexander. As advertised on its warehouse building and trucks, the company was Savannah's exclusive distributor of Tuxedo Feeds, boasting "the best feed for every need." The grocery also distributed a complete line of staple and fancy groceries, tobaccos, cigarettes, and candies and achieved distinction as the largest supplier of stores for ships. The building pictured below was the downtown distribution center at 112–120 West St. Julian Street. A Pinkussohn's cigar store occupied the corner retail space and painted an exquisite wall billboard on the building's Whitaker Street side. This building was later converted into the Ocoma Garage, providing automobile service and storage. The entire block was demolished in the early 1970s for a parking lot. (Above: Cordray-Foltz Collection #1360, Box 6, Folder 3, Item 7; Below: Cordray-Foltz Collection #1360, Box 13, Folder 1, Item 3.)

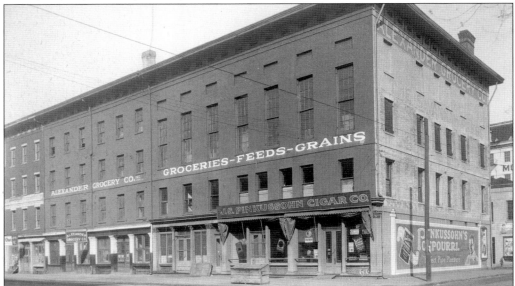

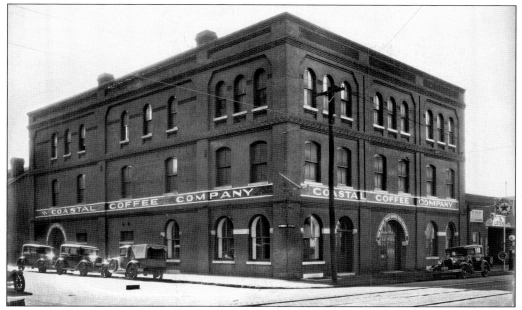

The Coastal Coffee Company was located in a warehouse at the southwest corner of Bay and Jefferson Streets. Painted over the building's arched doorways was the company's slogan: "The House That Gives You Service." This photograph also captured a small service station, complete with Texaco Star signage. A nightclub now occupies the former warehouse. (Cordray-Foltz Collection #1360, Box 9, Folder 12, Item 11.)

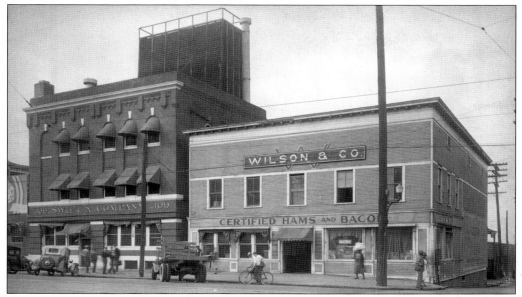

This 1934 photograph shows the clapboard building of Wilson & Company, distributors of certified hams and bacon. The retail and warehouse building once stood at 303 West Broad Street. The third floor of the building's front façade was used for advertising, which consisted of a large "W" overlapped with a signboard carrying the company's name. (Cordray-Foltz Collection #1360, Box 9, Folder 20, Item 5.)

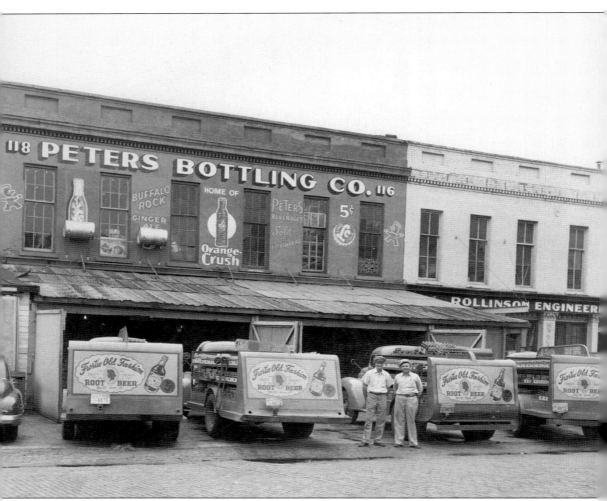

The offices and plant of Peters Bottling Company were located at 116–118 West Bay Street. Lined up in front of the building are the company's delivery trucks. The backs of the trucks carried advertisements for Frostie Old Fashion Root Beer, one of the soft drinks manufactured and distributed by Peters. The most popular product bottled by Peters was Orange-Crush. E.B. Peters was the president of the company, with P.F. Peters as secretary and treasurer. (Cordray-Foltz Collection #1360, Box 9, Folder 12, Item 6.)

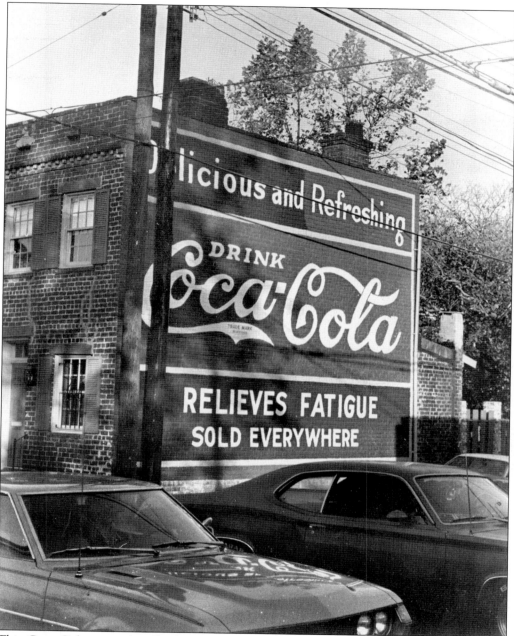

This Coca-Cola painted wall advertisement still exists on the row house at the corner of Price Street and Perry Lane. The Coca-Cola Company commissioned sign painters to seek out and secure walls like this one for advertising. The first Coca-Cola wall sign was painted by James Couden in 1894 on the side of Young and Mays drugstore in Cartersville, Georgia. Savannah's Coca-Cola bottling plant was once located on Bryan and Houston Streets. (Historic Savannah Foundation.)

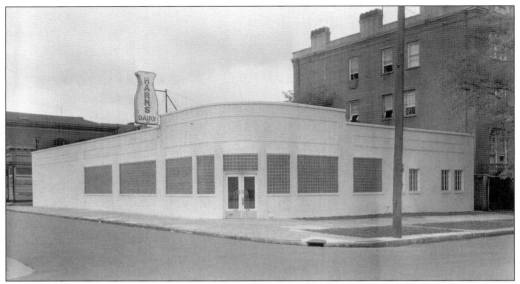

Since its founding in 1915, Harms Dairy was famous far and near for its Golden Guernsey milk. This West Jones and Whitaker Streets plant was built in 1940 to meet demands for larger volume and greater distribution. The milk was produced south of the city at Oakhurst Farms, a 400-acre dairy farm on White Bluff Road. Although the glass block windows and milk bottle sign no longer survive, the Art Moderne building remains in use. The dairy has been converted into a small shopping strip of specialty stores. (Cordray-Foltz Collection #1360, Box 13, Folder 19, Item 3.)

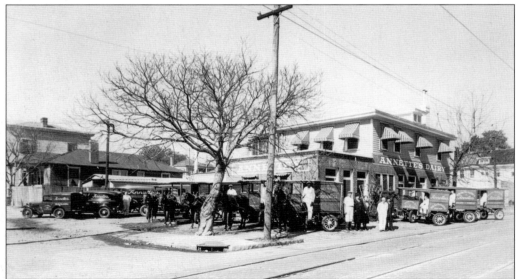

The delivery depot for Annette's Dairy was located at Habersham and 41st Streets. Famous for its "Milk for the Kiddies," Annette's was founded by Ernest C. Bull in 1919. The dairy introduced Savannah to irradiated vitamin D milk, homogenized milk, and Dacro sealed bottles. The barns, milking sheds, and grazing fields were south of Savannah in Chatham County. Annette's federally accredited herd of purebred Jersey cows was considered one of the finest herds in the South. (Cordray-Foltz Collection #1360, Box 12, Folder 2, Item 2.)

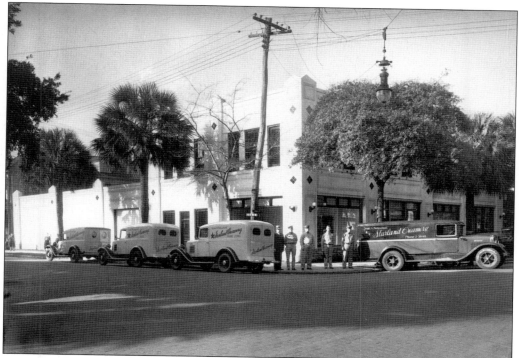

Built in 1935, the Starland Creamery at 2425 Bull Street advertised itself as "the most complete dairy plant in Savannah." Its herd of cattle was said to live "in luxury and contentment" on extensive pasture lands. The star, the symbol of the dairy, was printed on every bottle and was used as architectural decoration throughout the plant. The Starland management, headed by C.E. Oliver, offered the people of Savannah a standing invitation to visit their plant. Tourists could see the equipment and methods used to manufacture Starland milk. The dairy no longer exists, but the building has become the center of an art district. The plant and surrounding buildings are currently art galleries, gift shops, and cafés. (Above: Cordray-Foltz Collection #1360, Box 11, Folder 4, Item 2; Right: Cordray-Foltz Collection #1360, Box 11, Folder 4, Item 4.)

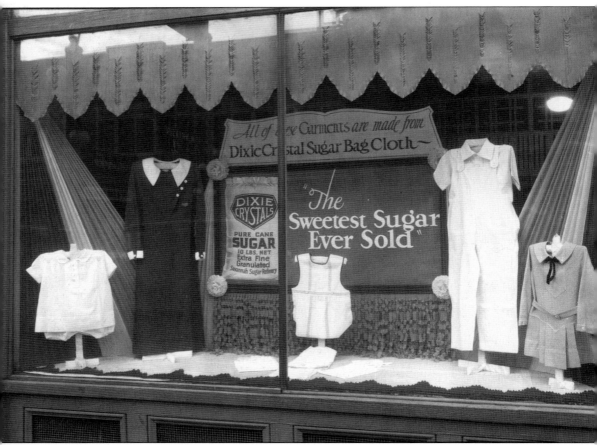

This Depression-era window display for the Savannah Sugar Refinery displays garments made from the cloth bags of Dixie Crystal Sugar. The Savannah Sugar Refinery opened its plant on the Savannah River in 1916. Dixie Crystals, "the sweetest sugar ever sold," became a household name and was distributed throughout the world. In the 1950s the refinery employed 700 people, and the company's importation of raw sugar was one of the port's largest receipts. (Cordray-Foltz Collection #1360, Box 6, Folder 2, Item 5.)

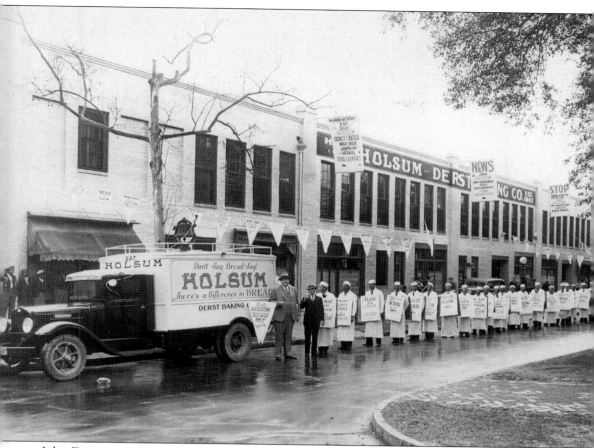

John Derst came to America in 1855 from Germany and worked in a Savannah bakery before the Civil War. In July 1867 the young Confederate soldier opened his own bakery with the following announcement: "John Derst, Variety Baker, Broughton Street Opposite the Marshall House. Breads, Cakes, and Pies Fresh Every Day. Cakes for Parties and Weddings Made at Short Notice." The baker became a city alderman and rose to the rank of captain as a member of the militia and volunteer fire department. His son Edward J. Derst took over the business in 1917. The bakery moved to the large plant at Oglethorpe Avenue and Habersham Street in 1924. This 1935 photograph shows the bakery's employees assembled for a parade in front of the Oglethorpe building. As advertised on the truck leading the procession, Holsum Bread was Derst's signature. In 1949 a new facility was built on the 52nd Street extension, which still operates today. (Cordray-Foltz Collection #1360, Box 6, Folder 4, Item 4.)

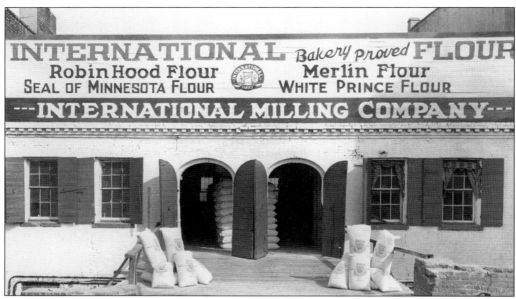

The International Milling Company was located at 222 West Bay Street. The company installed a wooden signboard above the building's brick cornice to advertise its "bakery proved" flours. Robin Hood Flour, Seal of Minnesota Flour, Merlin Flour, and White Prince Flour were the brands supplied by International Milling. (Cordray-Foltz Collection #1360, Box 9, Folder 12, Item 10.)

Bart's Bakery was first organized by C.A. Bart in 1894. The first location of the company was at West Broad and Wayne Streets. Three years later it moved to Charlton and West Broad Streets. In 1908 Bart's relocated to Bull and 42nd Street as shown above. The modern brick addition was constructed in 1925 to expand and modernize the plant. Bart's Cream Bread with "Magic Mould Retarder" was extremely popular with Savannahians. The bakery closed in 1966. (Cordray-Foltz Collection #1360, Box 11, Folder 4, Item 11.)

Five

RESTAURANTS AND BARS

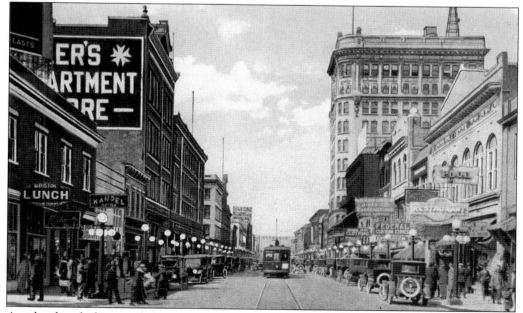

Amidst the clothing and department stores, this block of East Broughton between Bull and Drayton Streets was home to several restaurants and bars. Bristol Lunch, 31 East Broughton Street, appears in this 1924 postcard. The Olympia Restaurant was across the street in the Lamas Brothers' building. Above the Olympia was the Arcade Pool Room. (Author's collection.)

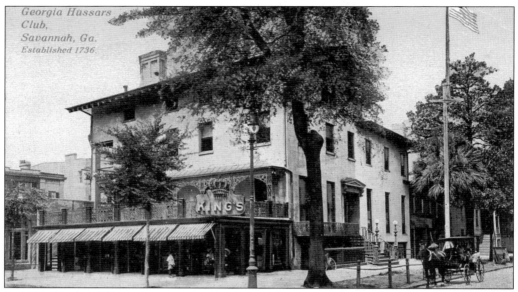

In 1912 King's sold ice cream, sandwiches, and soda water at the southwest corner of Bull and Liberty Streets. The business had a rather exquisite incandescent bulb sign topped with a crown. The retail space occupied by King's was constructed in the late 1890s by the Georgia Hussars, a cavalry unit that used the house next door as its armory and headquarters. Before the Georgia Hussars, the house, designed by John Norris in 1849, was home to the De Renne family. (Author's collection.)

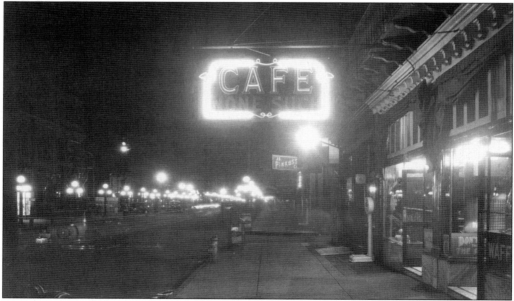

This exceptional photograph captured the nighttime illumination of Broughton Street in the 1930s. At its center is the neon sign of None Such Café, originally called None Such Quick Lunch. The restaurant opened in 1921 at 104 East Broughton Street. Visible across Drayton Street was the projecting sign of the J.S. Pinkussohn Cigar Company. (Cordray-Foltz Collection #1360, Box 7, Folder 9, Item 10.)

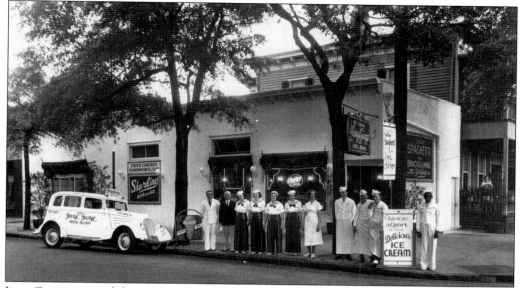

Jerry George opened this restaurant at 1518 Bull Street around 1932. As the neon sign over the entrance advertised, the business sold "ice cream," "eats," and "drinks." The waitresses dressed in delightful sailor suits. George kept this restaurant open until 1954. (Cordray-Foltz Collection #1360, Box 11, Folder 2, Item 2.)

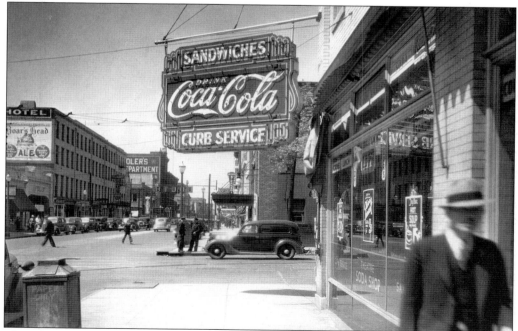

This neon Coca-Cola swing sign projected over the corner entrance to the Theater Soda Shop. Located at the northeast corner of Broughton and Abercorn Streets, the Theater Soda Shop was opened in September 1934 by Thomas L. Morris. With the theaters nearby, moviegoers would stop at the shop for refreshments. (Cordray-Foltz Collection #1360, Box 10, Folder 1, Item 4.)

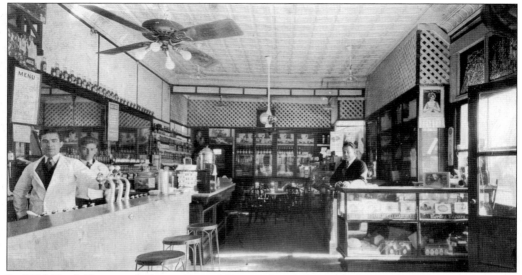

In 1919 Basil, Peter, and George Leopold opened a modest soda fountain and restaurant at the northeast corner of Habersham and Gwinnett Streets. The brothers started serving homemade ice cream in the 1920s, and the shop became known as one of the sweetest spots in town. Leopold's was a favorite after-hours stop for Savannahians who desired to top off their evening with a black and white or a dish of tutti frutti. The business was one of a few in town offering curb service. Curb boys and girls hustled back and forth between the fountain and hungry motorists parked outside. Located beside a streetcar stop, commuters would drop in for a quick scoop of ice cream while waiting to transfer cars. The 1930s interior photograph shows Peter behind the glass counter and Basil with an unidentified soda jerk behind the fountain. Outside the shop in the 1950s photograph below is Peter's family, from left to right, daughter Beki (seated), wife Marika, and son Stratton. The Habersham shop closed in 1968–1969. To the excitement of Savannahians who remember his father's shop, Stratton and his wife Mary have reopened Leopold's Ice Cream at 210–212 East Broughton Street. (Courtesy of Stratton and Mary Leopold.)

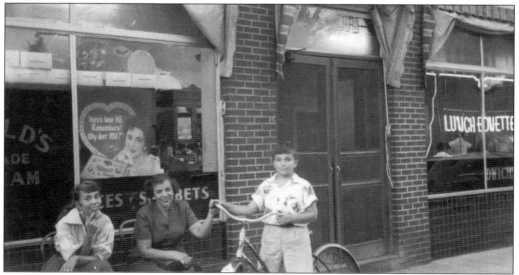

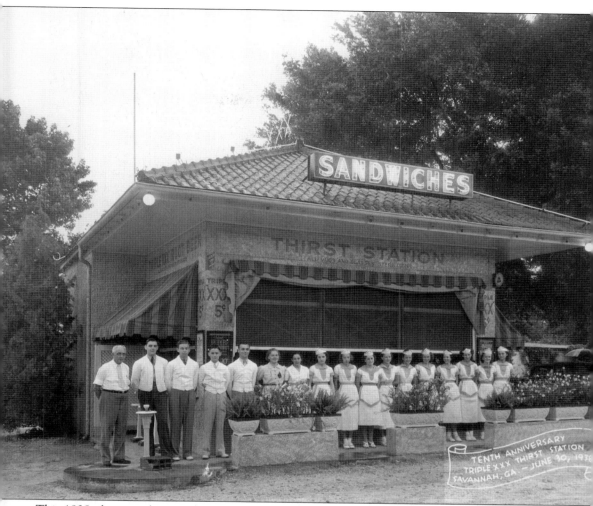

This 1938 photograph was taken to celebrate the 10th anniversary of the Thirst Station. The man starting the lineup at the left is J.B. Dodge, founder and owner. This drive-up restaurant once stood at 1402 East Victory Drive and specialized in sandwiches and Triple XXX root beer. The building was illuminated at night with neon in the form of a "sandwiches" sign, tubing along the roof lines, and an "XXX" sign on the very top. (Cordray-Foltz Collection #1360, Box 7, Folder 9, Item 13.)

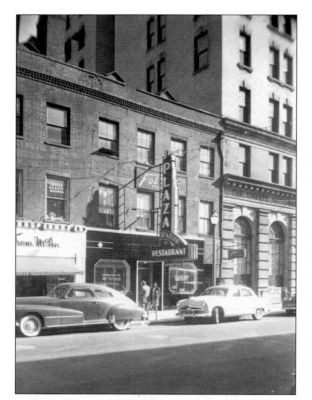

The Plaza Restaurant, established in 1915, was located at 12 West Broughton Street. In 1937 owner Anthony Andris remodeled the Plaza, installing a black Carrara Glass veneer, octagonal windows, and a large vertical neon sign. The new interior boasted red, yellow, and green leather booths and modern tables with chromium trimmings. The photograph below shows the kitchen crew at a Christmas party. Located above the Plaza Restaurant were the offices and studio of Foltz Photography. A large portion of the pictures in this book were taken by this photography house. In 1950 the name of the Plaza was changed to Anton's. The restaurant building, along with the neighboring Liberty National Bank, was demolished in 1975. (Left: Cordray-Foltz Collection #1360, Box 10, Folder 8, Item 1; Below: Cordray-Foltz Collection #1360, Box 10, Folder 8, Item 8.)

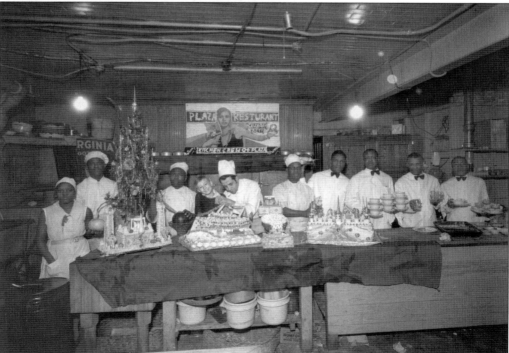

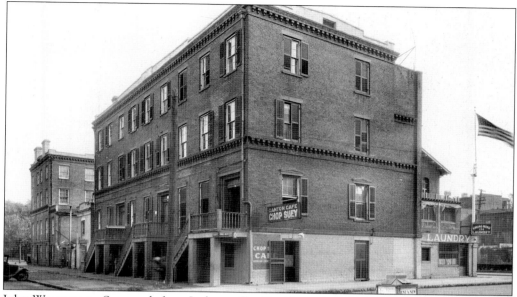

John Wu came to Savannah from Jacksonville, Florida, and opened the Canton Café in 1930. The restaurant's first location, pictured above, was at the corner of Drayton and President Streets, facing the old Chatham County Courthouse. This row of houses was later demolished, and Canton moved to the southeast corner of Abercorn and York Streets, shown below, in 1960. John Wu and his wife Lancy Sheng Wu designed the pagoda-topped neon sign. Acting under a new ordinance restricting neon in the historic district, the city sought to have Canton's sign removed in 1983. The city lost the battle thanks to extensive support from the restaurant's customers. Canton was the city's oldest Chinese-American restaurant and one of the city's oldest easting establishments when it closed in 1991. The metal awning still exists, but the neon sign was sold soon after the restaurant shut its doors to business. (Above: GHS Photo Collection #1361 PH, Box 13, Folder 2, Item 2666; Below: Historic Savannah Foundation.)

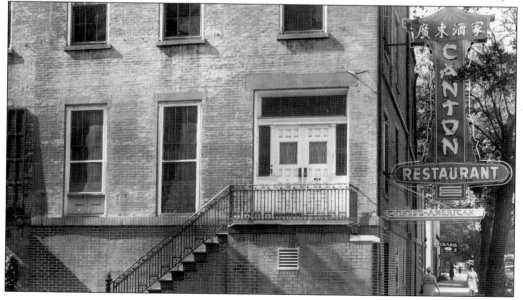

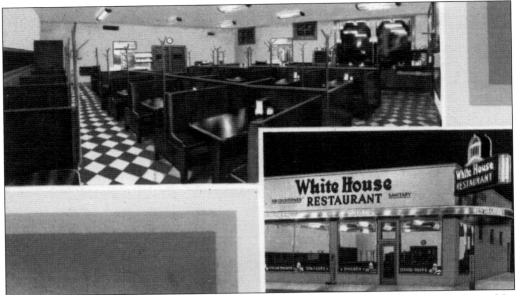

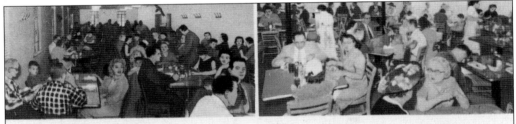

This postcard shows the White House Restaurant, which opened in the mid-1940s. Owned by the Mustakas Brothers, the restaurant specialized in seafood and steaks. The building at the corner of Montgomery Street and Oglethorpe Avenue has been significantly altered and now houses the Chao Chinese Restaurant. (Author's collection.)

Tom Williams and his wife, Leila "Mom" Williams, started Williams Seafood as a roadside stand in 1936. The popularity of Mrs. Williams' deviled crab allowed the enterprise to expand. Their son Hubert Williams and his wife, Martha, later joined the family business. In 1950 the restaurant pictured here was constructed. With seating for nearly 500 people Williams Seafood had grown into a Savannah institution. Still going strong, the restaurant is run by Tommy and Carol, the third generation of the Williams family. (Author's collection.)

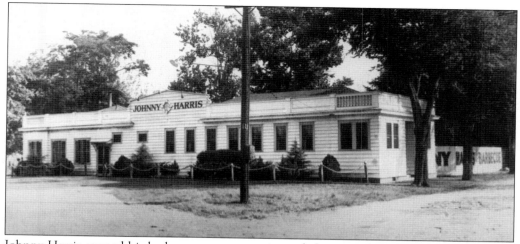

Johnny Harris opened his barbecue restaurant, pictured above, at the corner of Bee Road and Victory Drive in 1924. Kermit "Red" Donaldson joined Harris in 1927, and together they created a flourishing business. The white clapboard building became too small to handle the crowds, so a new brick building at 1651 East Victory Drive was erected in 1936. The postcard below shows the new restaurant, its "bar-be-cue" pit, and the main dining room. The 3,000-square-foot, polygonal, maple dance floor of the dining room was the highlight of the new building. Twenty-four booths surrounded the dance floor. The "lighthouse," an air-conditioned tower with revolving lights, stood at the center of the room. Johnny Harris died in 1942, and Red Donaldson continued on as manager and part-owner. In 1955 Donaldson purchased full control of the business. During his ownership, the Johnny Harris Famous Bar-B-Que Sauce Company was created to distribute the restaurant's popular sauces. Donaldson died in 1969 and passed the business on to his children and son-in-law Norman L. Heidt, who is now president and general manager. (Above: GHS Photo Collection #1361 PH, Box 7, Folder 16, Item 1396; Below: Author's collection.)

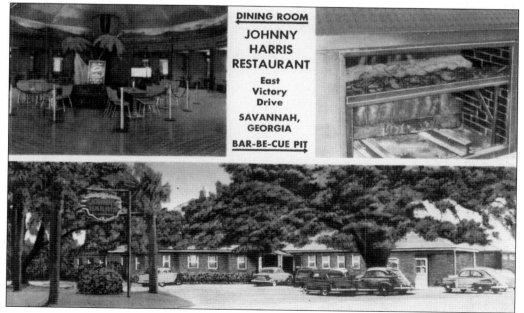

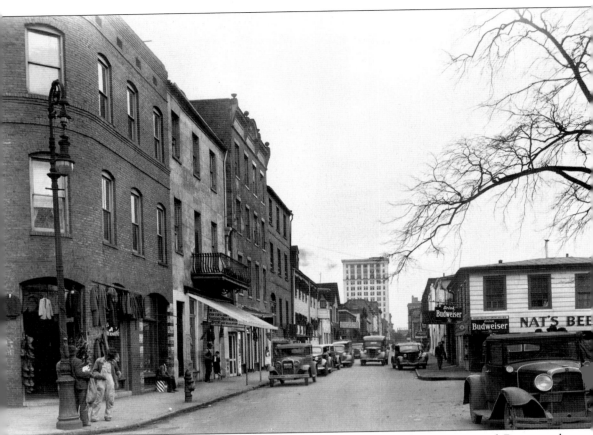

Nat's Beer Parlor was located on Franklin Square at the southeast corner of Bryan and Montgomery Streets. Owned by Nat Weinberg, the lunch and beer establishment opened in 1937. By 1940 Weinberg had renamed the spot the Sea Breeze Tavern. The business expanded with a move across the street to 320–322 West Bryan in 1947. This had been the location of Louise's Place, another popular bar. The Sea Breeze Tavern stayed open until the entire block of buildings was demolished in 1971. The frame building of Nat's Beer Parlor survives and is the home of Vinnie Van Go-Go's, which serves pizza and beer. (Cordray-Foltz Collection #1360, Box 10, Folder 20, Item 12.)

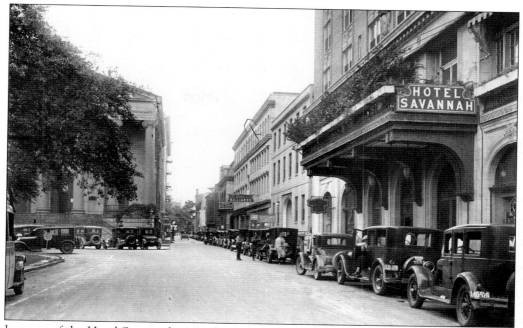

Just east of the Hotel Savannah at 17 West Congress Street was Bo Peep's, "where amateurs as well as experts gather to play the fascinating games of billiards and pool, to get quick sports returns, and to enjoy lunches that are served quick and appetizingly." Owned by Wolfe Silver, Bo Peep's opened around 1926 and was a favorite lunch spot and bar for downtown businessmen. The interior photograph below was taken in 1932. This row of buildings was leveled in the early 1960s for parking lots. (Above: GHS Photo Collection #1361 PH, Box 9, Folder 9, Item 1857; Below: Cordray-Foltz Collection #1360, Box 11, Folder 8, Item 2.)

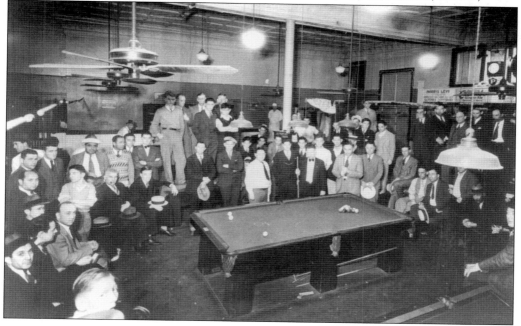

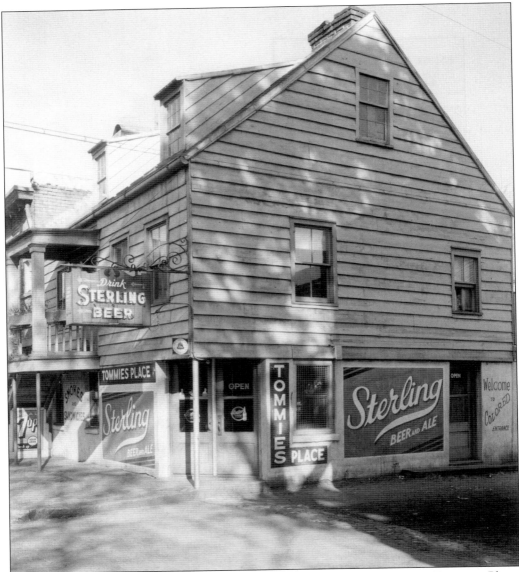

The first floor of this simple frame structure at 38 Price Street was home to Tommies Place. Owned by Mrs. Leona Figg, the bar and lunch spot promoted Sterling Beer and Ale with wall paintings and a neon sign. The elaborate wrought-iron bracket and "wooden" gate neon sign strangely complemented the building's rustic character. (Historic Savannah Foundation.)

Six

DRUGS AND TOBACCO

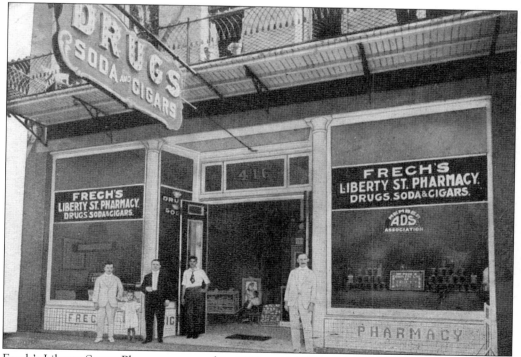

Frech's Liberty Street Pharmacy opened in 1907 at 416 West Liberty Street. Before starting his own business, Henry C. Frech was a clerk for W.A. Pigman, another druggist, with stores at 332 West Liberty Street and 416 West Broad Street. Frech's shop had a diversity of signage. Below the shop windows, the name of the business was spelled out in tile. The large expanses of glass were decorated with gold-leaf signs. Above the entrance was an ornate hanging sign with the word "drugs" electrified and lit with incandescent bulbs. The pharmacy stayed open until 1940. (Author's collection.)

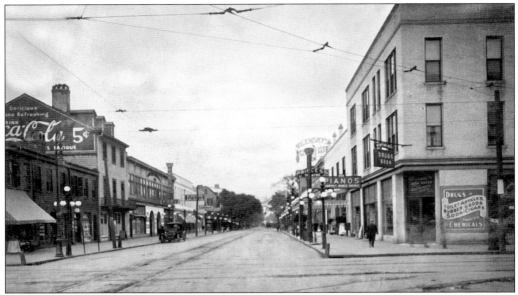

Visible on the right of this 1914 photograph is the corner drugstore of McIntyre & Hitt. The shop was located at the intersection of East Broughton and Abercorn Streets. Before McIntyre & Hitt, the pharmacy was owned by Robert D. Hamilton. In 1913 W.R. McIntyre and A.M. Hitt purchased the business. McIntyre had previously been a chemist for Solomons Drug Company, and Hitt had been a traveling salesman. The photograph also includes signs for the Murphy Music House, the Princess Theater, and Wilensky's Shoes. (GHS Photo Collection #1361 PH, Box 9, Folder 1, Item 1706.)

Walter D. Jones was the proprietor of Jones' Pharmacy at 241 Bull Street and Perry Lane. The side of the building facing the lane was covered with a Pepsi-Cola wall advertisement. The business was open from 1897 to the late 1940s. (Cordray-Foltz Collection #1360, Box 12, Folder 18, Item 12.)

The first floor of the Masonic Temple, pictured in the postcard to the right, was home to the retail drugstore of the Solomons Company. Abraham Solomons, founder of the company in 1845, came to Savannah from Georgetown, South Carolina. He obtained South Carolina's first druggist license in 1835. By 1948 the wholesale drug company had grown to serve three states. Proud of its heritage, the company displayed an April 20, 1870 prescription for Gen. Robert E. Lee. During the 1950s and 1960s the pharmacy's soda fountain was a popular hangout for moviegoers at the Savannah Theater across Madison Square. Pharmacist Roy Thomas purchased the store in 1974 and kept the business going until 1981. The stained glass mortar and pestle windows, Tiffany-style glass globes, and mahogany woodwork survived. The space was reincarnated as the Gryphon Tea Room. (Right: Author's collection; Below: Cordray-Foltz Collection #1360, Box 10, Folder 24, Item 14.)

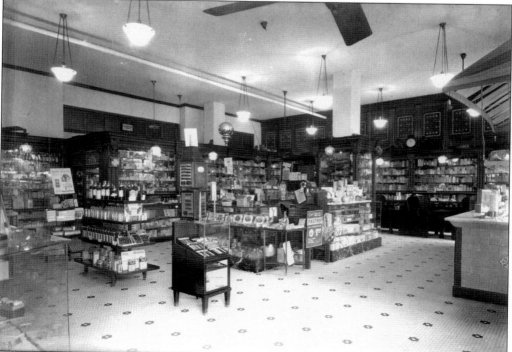

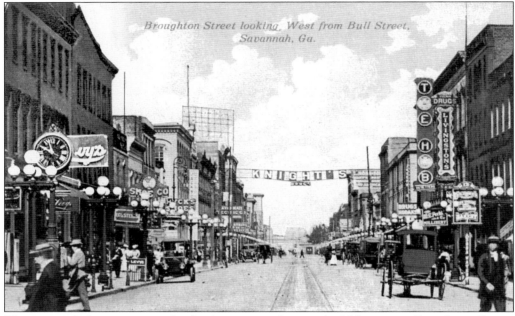

The postcard above portrays the lively activity along early 20th-century Broughton Street. Avoiding the visual clutter along the sides of Broughton, Knight's Pharmacy stretched a sign over and across the commercial strip. Opening in 1906, the 103 West Broughton Street store became the headquarters for a chain of drugstores started by W.T. Knight Sr. in 1890. By 1914–1915 the Broughton Street shop had moved across the street to 104 West Broughton, shown at the right of the photograph below. W.T. Knight II later became president of the company and helped establish WTOC, Savannah's first radio station. (Above: Author's collection; Below: Cordray-Foltz Collection #1360, Box 10, Folder 11, Item 3.)

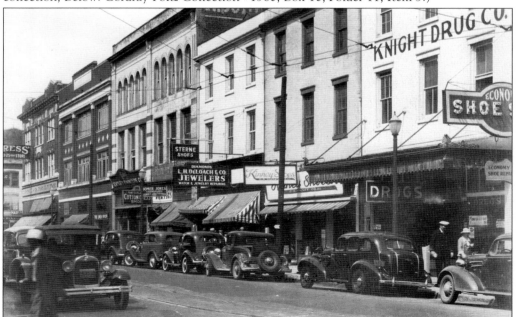

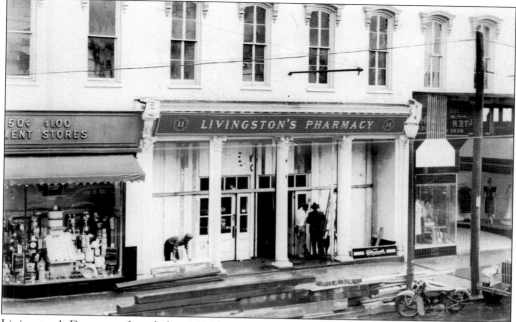

Livingston's Drugs was founded in 1886 by Henry H. Livingston. The original shop was located at the corner of Bull and State Streets. The store moved numerous times, and Livingston's grew to several locations. In 1928 Livingston's opened its 11 West Broughton Street store. The photograph above documented the storefront's remodeling in September 1938. Below is the finished product. The sidewalk scales, gilded window signs, and neon Coca-Cola sign enticed pedestrians and motorists to take a look inside. (Above: Cordray-Foltz Collection #1360, Box 10, Folder 8, Item 4; Below: Cordray-Foltz Collection #1360, Box 10, Folder 8, Item 6a.)

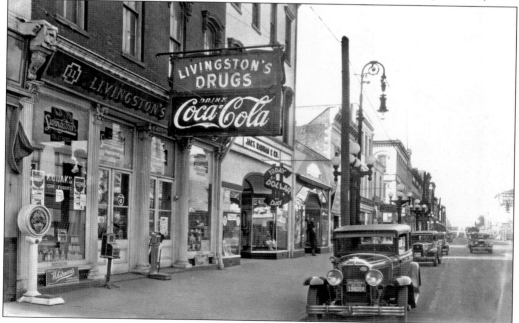

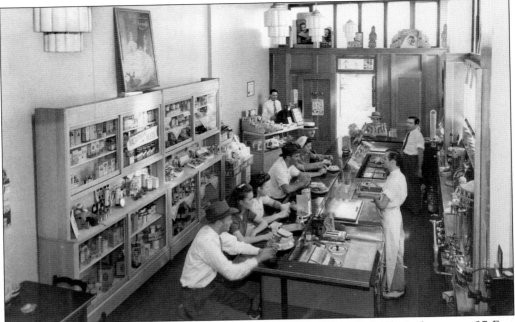

A typical lunchtime crowd is seated along the fountain of Joseph Geffen's drugstore, 27 East Broughton Street, in this 1940s photograph. The soda fountain, once a drugstore staple, served as a gathering place for swapping news and gossip. Commercial ice cream, bottled soft drinks, and fast food restaurants led to the gradual disappearance of soda fountains. Above Geffen's cabinets of pharmaceutical goods was a framed poster for Nunnally's, "the candy of the South." (Cordray-Foltz Collection #1360, Box 9, Folder 27, Item 3.)

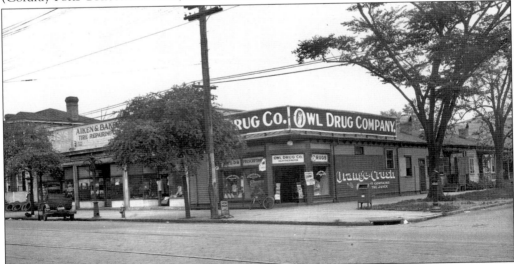

The Owl Drug Company was at the corner of West Broad and Hall Streets. Harry G. Witherington was the company's pharmacist in the early 1930s. Rooftop signboards carried the store's name; an owl was painted to perch within the O. An Orange-Crush advertisement covered the drugstore's Hall Street façade. (Cordray-Foltz Collection #1360, Box 9, Folder 21, Item 8.)

The wooden Indian at the corner and a wooden sign decorated with a pipe identified this gambrel-roofed frame building as a tobacco shop. Meyer's Tobacco, 35 Whitaker Street, was located at the intersection of Whitaker and President Streets. An 1877 advertisement stated that Meyer's "keeps constantly in hand the best and cheapest segars, tobacco, pipes, and all articles in this line." Beside Meyer's was a two-story building with a hipped roof and double entrance. In 1799 this became the first home of Solomon's Lodge. (GHS Photo Collection #1361 PH, Box 7, Folder 9, Item 1279.)

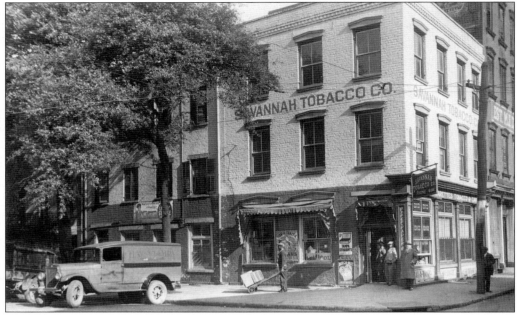

The Savannah Tobacco Company, established in 1909, was one of the leading wholesale distributors of tobaccos, cigars, beers, ales, and candies in the Southeast. The offices and warehouses were located at 18 Barnard Street. In their territory, the company was the exclusive agent for the well-known Hav-A-Tampa cigars. Parked out front is a delivery truck with a Hav-A-Tampa advertisement painted on its side. True-Blue, Pabst, Blue Ribbon, and Horton's were among the beers and ales distributed. Boxes of Lucky Strike, Cremo, and Prince Albert tobacco were stacked in the storeroom shown below. (Above: GHS Photo Collection #1361 PH, Box 8, Folder 5, Item 1451; Below: Cordray-Foltz Collection #1360, Box 9, Folder 9, Item 3.)

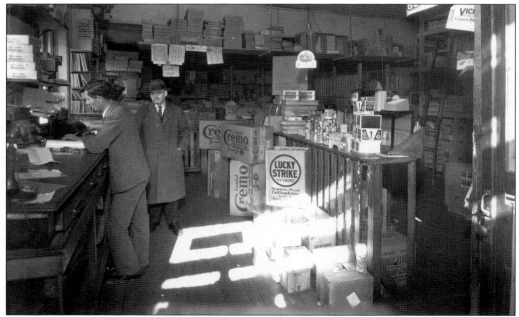

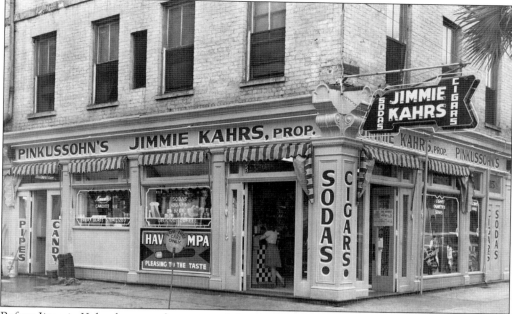

Before Jimmie Kahrs became the owner of this Pinkussohn's Cigar Shop in 1941 he worked as a clerk for the Solomons Company and as a salesman for J.H. Smith. The shop was located at the corner of Bull and Bryan Streets in the Pulaski Hotel building. The arrow sign and frieze were outlined with neon tubing to illuminate the business's name at night. In addition to selling tobacco products, the shop operated as a luncheonette. Opposite the tobacco counter shown in the photograph below was a full-service soda foundation. (Above: Cordray-Foltz Collection #1360, Box 10, Folder 22, Item 9; Below: Cordray-Foltz Collection #1360, Box 10, Folder 22, Item 11.)

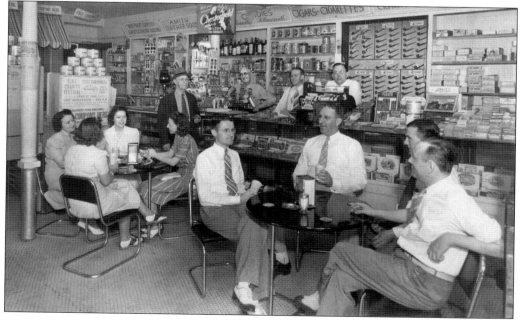

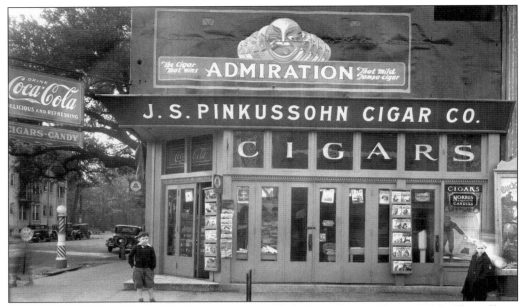

The J.S. Pinkussohn Cigar Company was established in Savannah in 1885. The offices, warehouses, and wholesale department were located at 225 East Bay Street. By the late 1930s Pinkussohn's operated nine retail stores throughout the city. Many of these stores were on the most prominent business corners in Savannah and became landmarks. The Pinkussohn family operated the company until it was purchased by Charles L. Duke and J.R. Howard. In addition to tobacco products of all kinds, the stores had soda fountains and lunch counters. A specialty of the company was Pinkussohn's Potpourri smoking tobacco. Pinkussohn's was also the sole distributor for the Thompson Cigar Company, a Savannah cigar manufacturer. Thompson's brands were called General Oglethorpe, Chatham Smoke, and Savannah Maid. The photographs show two of Pinkussohn's retail stores. The upper stories of the shop above, at the corner of Abercorn and East Broughton, were covered with metal to provide a surface for elaborately painted advertisements. The store below took advantage of its side wall to advertise Sovereign Cigarettes. (Above: Cordray-Foltz Collection #1360, Box 10, Folder 2, Item 8; Below: Cordray-Foltz Collection #1360, Box 6, Folder 9, Item 9.)

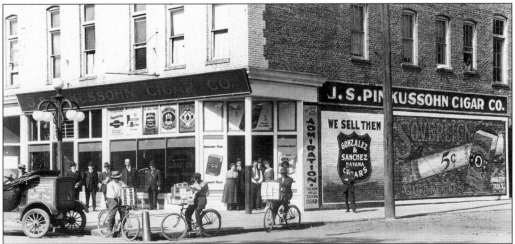

Seven

THEATERS

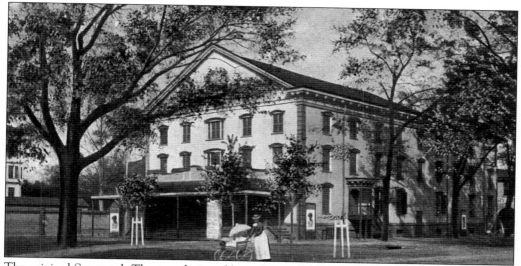

The original Savannah Theater, designed by architect William Jay, is pictured in this postcard. Located on Bull Street, facing Chippewa Square, the Savannah Theater opened on December 4, 1818, with the comedy *The Soldier's Daughter* and the farce *Raising the Wind*. The building's restrained exterior gave no indication of the lavish interior. Above the proscenium arch, flanked by four pilasters, loomed a painting of the goddess of arts. Cast-iron columns with gilt capitals and bases supported the gallery and two tiers of boxes. Eagles, wreaths, and Greek frets decorated the box fronts. (Author's collection.)

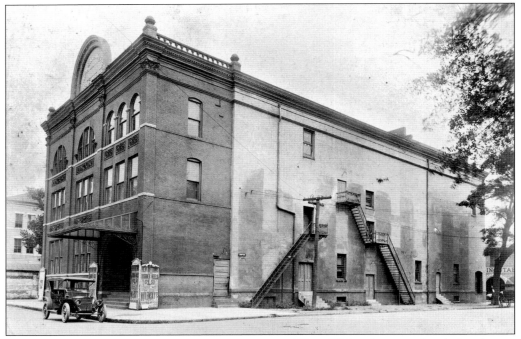

Albert Weis, who owned a chain of playhouses, became the principal owner of the Savannah Theater in the 1890s. Fire gutted the building in September 1906, and only the north and south walls of the original building were saved. The theater was rebuilt, and by 1931 it had been fully converted into a movie house. In 1948 fire again destroyed the building. Fred G. Weis, the son of Albert Weis, was then owner of the theater. He employed Robert E. Collins of Miami to design a new structure. The "ultra-modern Savannah Theater," opening in October 1950, was described as "a new era in local cinema design." The building occupied the entire block, and "its massiveness and multi-colored neon lighting rising above a beautiful façade" created a striking effect. The interior was air conditioned and outfitted with a Cycloramic screen, front contour curtain, and Kroehler push-back seats. In 1993 all the neon was replaced, new bulbs were installed in the "Savannah" vertical sign, and most of the marquee's backing glass was replaced. (Above: Cordray-Foltz Collection #1360, Box 3, Folder 6, Item 5; Left: Historic Savannah Foundation.)

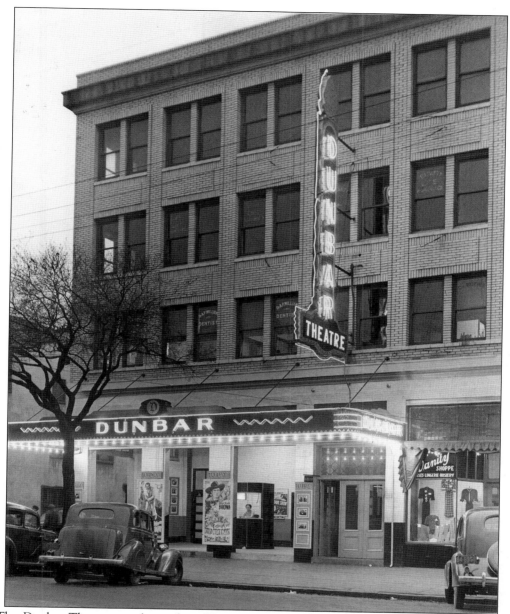

The Dunbar Theater was located on West Broad Street between Alice and Gaston Streets. Walter Sanford Scott, an African-American Savannah businessman, built the five-story theater in 1921. The first movie shown there was *Symbol of the Unconquered* by the pioneer African-American filmmaker Oscar Micheaux. Along with movies the theater featured live, late-night blues shows called "midnight ramblers." Local jazz acts like Al Cutter, Raymond Snype, and the Snappy Six were regular performers. Little Richard, Little Ester, Sammy Davis Jr., the Will Mastin Trio, and many others also performed at the Dunbar. The upper floors of the building housed a hotel and offices of African-American doctors and dentists. The theater building was demolished to make way for the Interstate 16 overpass in the early 1960s. (Cordray-Foltz Collection #1360, Box 3, Folder 3, Item 3.)

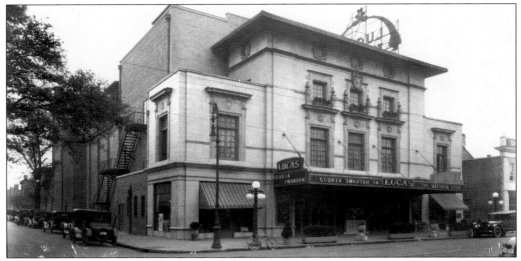

Designed by noted theater architect Claude K. Howell, the Lucas opened on December 26, 1921. A *Savannah Morning News* article described the building's signage as follows: "Over the entrance of the lobby will be an ornate marquise of wrought steel, held to the building by specially designed supports. Lights of great intensity will be distributed underneath the marquise giving the front of the house the appearance of daylight. On the roof a huge sign of the latest design will flash the fact for miles that the Lucas Theatre is open for the amusement of the Savannah public." The above image shows the original marquee; below is the 1930s neon replacement. The Lucas Theatre was named for owner Arthur Lucas. The Savannahian began his theater empire in his hometown in 1907, gradually building it to 40 theaters throughout Georgia, including Atlanta's Fox Theater. The Lucas closed in 1976 and was threatened with demolition. Lovingly restored, it reopened in 2000. (Above: Cordray-Foltz Collection #1360, Box 3, Folder 2, Item 6; Below: Cordray-Foltz Collection #1360, Box 3, Folder 2, Item 10.)

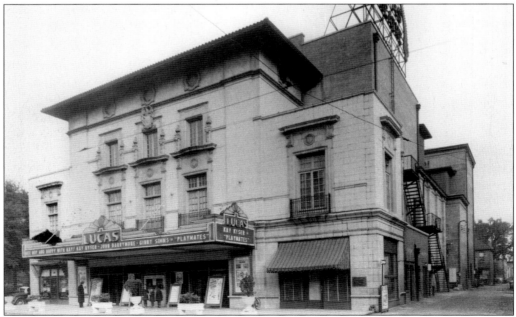

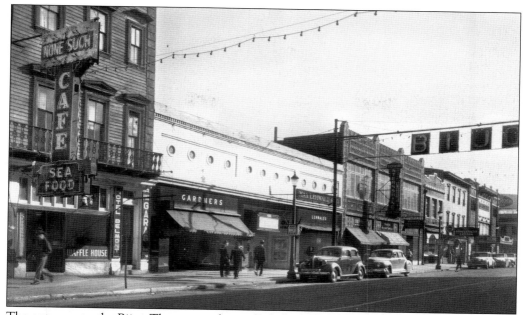

The entrance to the Bijou Theater was located on the 100 block of East Broughton Street. The 1,100-seat auditorium stood across the lane on Congress Street. Part of the Lucas chain, the Bijou showed movie and stage productions like Keith's Vaudeville. The Bijou had a sign, visible in the photograph above, that stretched across Broughton Street during the 1930s. The photograph below shows the theater in the 1940s. By this time the sign over Broughton had disappeared. The entrance was remodeled with a new façade, and a marquee, topped with freestanding neon letters, was installed. The auditorium was later demolished for a parking deck. (Above: Cordray-Foltz Collection #1360, Box 10, Folder 1, Item 2; Below: GHS Photo Collection #1361 PH, Box 9, Folder 11, Item 1872.)

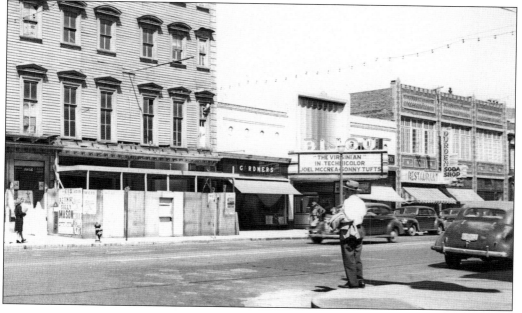

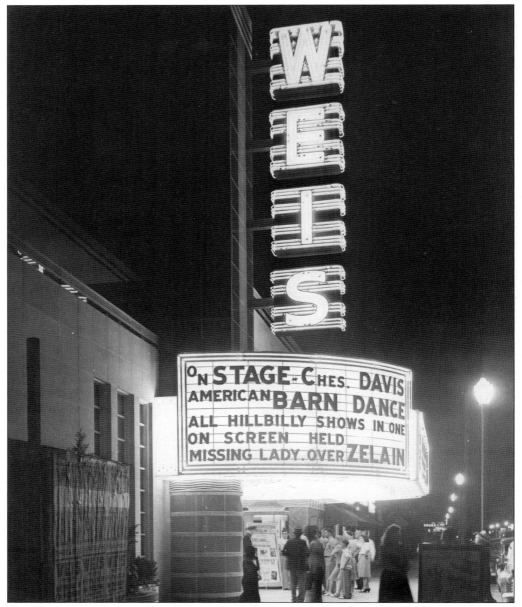

The Weis Theater opened on February 14, 1946, as part of a chain owned by Fred G. Weis. Weis also owned the Savannah, Roxy, and East Side Theaters in Savannah and the Bibb Theater in Macon. The building was designed by Tucker and Howell of Atlanta and constructed by the Span-Worrell Construction Company of Savannah. On opening day the *Savannah Morning News* described the façade as "ultra-modern." "Done in glass and the latest metal combinations, the beautiful front" was celebrated as "a distinct asset to the Savannah business district." The elaborate neon marquee is still a landmark on East Broughton Street. When the Savannah College of Art and Design acquired the building, the theater was renamed the Trustees Theater. The Weis letters were replaced with those of the college's acronym, SCAD. (Cordray-Foltz Collection #1360, Box 3, Folder 7, Item 1.)

Looking west down Broughton from Abercorn Street, the 1930s Savannahian could see the Odeon (at the northeast corner of the intersection), Arcadia (beside J.S. Pinkussohn Cigar Company on the south side of the street), Folly (just west of the Gilbert Hotel), and Bijou Theaters (on the north side of the street marked by its street-spanning sign). At one point, Arthur Lucas owned all of these theaters. Robbie Hardee, manager at the Arcadia, started a concept called "bank night" in 1925 to increase attendance. The theater put up $25 in prize money, and each person buying a ticket was entered into the raffle. A rather unpleasant rumor existed about the Folly Theater. Eating in theaters attracted rats, and the Folly was so infested that people kept their feet up during shows. (Cordray-Foltz Collection #1360, Box 10, Folder 1, Item 3.)

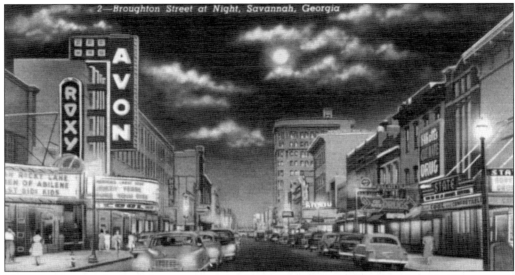

These two postcards show the same view in the 1950s and the 1960s. The Arcadia Theater was acquired by Mr. and Mrs. Fred G. Weis and renamed the Roxy in 1941. The Artley Company, a well-known local contractor, remodeled the street front with a neon marquee and vertical sign. The Odeon became the State by 1950. The Folly Theater, renamed the Band Box in 1942, was demolished and replaced by the Avon in 1944. The Avon's 1,277-seat auditorium was actually located across Broughton Street Lane on State Street. A covered passageway across the lane connected the arcade entrance to the main body of the theater. The theater closed in 1970, and the vertical neon sign was removed. The auditorium was later demolished to make way for a city parking deck, but the arcade was rehabilitated into a small theater that was home to an independent theater group called City Lights. In 2004 the space was once again modified to accommodate a restaurant. The semicircular marquee survives to serve as restaurant signage. The Roxy was demolished for a new Woolworth's store, which opened in 1954. The State was razed and replaced by the International-style First Federal Savings Bank building in 1960. (Author's collection.)

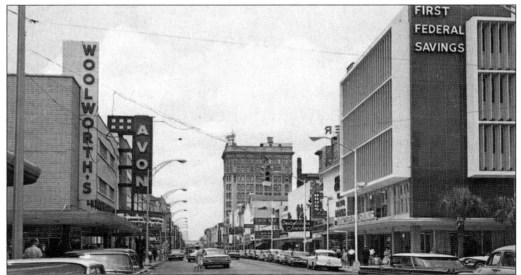

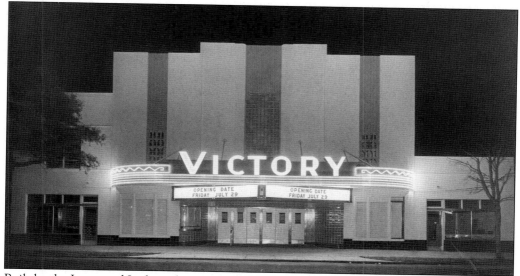

Built by the Lucas and Jenkins theatrical interests, the Victory Theater at Bull and 41st Streets opened on July 29, 1938. The Victory was called Savannah's "first neighborhood picture house" and "the city's first modernistic building." The façade, constructed of glass brick with silver metallic trimmings, was illuminated from behind to give a succession of different colors across the front. The hundreds of feet of neon in the marquee had a red, white, and blue color scheme. (Cordray-Foltz Collection #1360, Box 3, Folder 4, Item 2.)

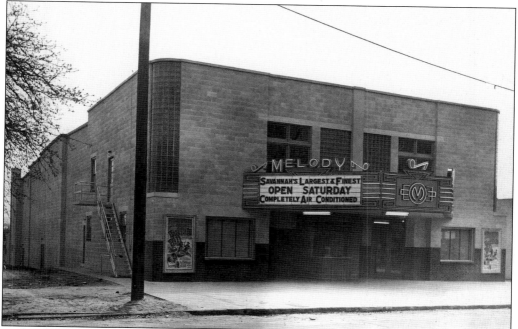

The Melody at 712 East Broad Street opened in the late 1940s. The marquee advertised the theater as "Savannah's Largest & Finest." Curved corners of glass block and neon musical notes on the marquee gave the building some architectural distinction. (Cordray-Foltz Collection #1360, Box 3, Folder 6, Item 1.)

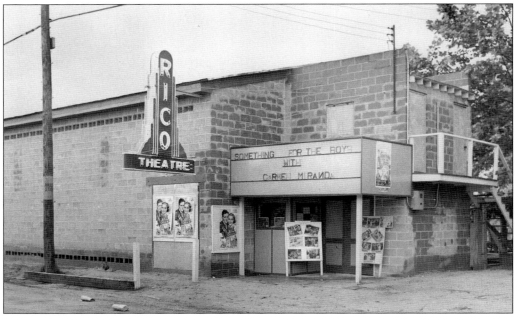

Although modest, this concrete block building (location unknown) fulfilled its purpose. The Rico Theatre's neon sign contrasts with the structure's simplicity, creating a wonderful juxtaposition. (Cordray-Foltz Collection #1360, Box 3, Folder 3, Item 9.)

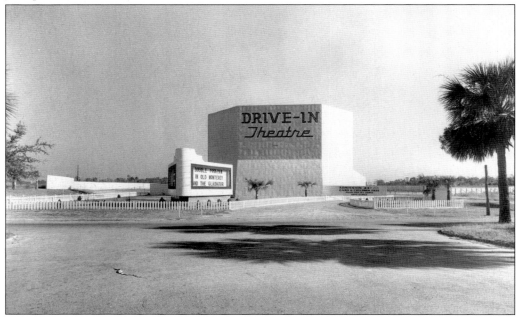

The Drive-In Theatre on Victory Drive opened on July 28, 1938, as Savannah's first open-air moving picture venue. The drive-in could accommodate 200 automobiles, and the screen was 40 feet wide. Other Savannah drive-in theaters were the Dixie Drive-In on Route 80 and the Montgomery Drive-In on Montgomery Street near De Renne Avenue. (Cordray-Foltz Collection #1360, Box 3, Folder 4, Item 13.)

Eight
HOTELS AND MOTELS

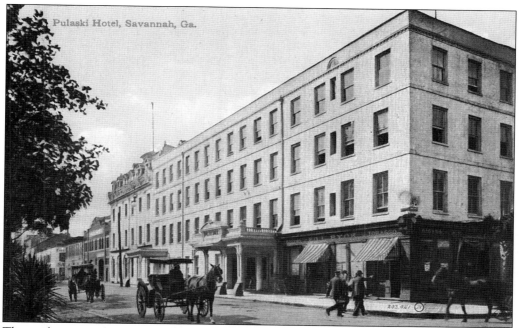

Pulaski Hotel, Savannah, Ga.

This early postcard image captured horse-drawn carriages passing by Savannah's most famous hostelry, the Pulaski Hotel. Occupying the northwest corner of Bull and Bryan Streets, the hotel dates back to the early 19th century. In 1848 it belonged to Peter Wiltberger, a retired ship veteran, who owned the building, the servants, and the furniture. The hotel was noted in those days for the excellence of its wines, and its central location made it the hub of activity for the bustling city. At the Pulaski, Savannah's planters, statesmen, and community leaders discussed crops, planned overseas shipping ventures, debated politics, and entertained guests. In 1850 the Pulaski became the first hotel in Savannah to use gas. (Author's collection.)

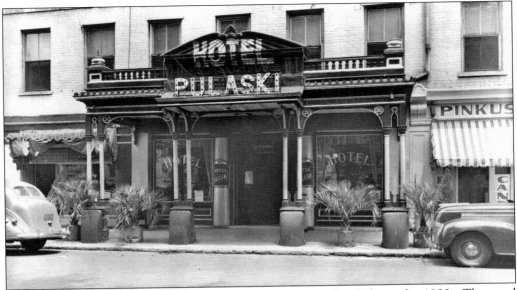

Neon tubing lit the elaborate entrance canopy of the Hotel Pulaski in the 1930s. The word "Pulaski" had previously been illuminated with a series of incandescent bulbs. To the right of the entrance, notice the signboard over the awning. A Pinkussohn Cigar Company shop operated out of this retail space. The building was demolished in 1956. (Cordray-Foltz Collection #1360, Box 7, Folder 2, Item 6.)

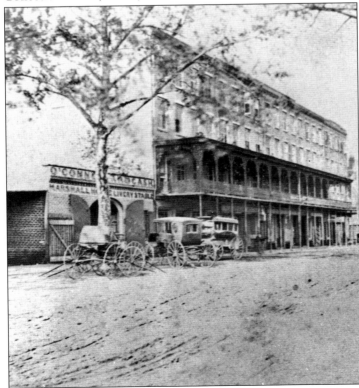

This photograph of the Marshall House and its livery stable was taken before 1870. The opening of the Marshall House in 1851 helped secure Broughton Street as Savannah's primary commercial corridor. On the hotel's opening day, the editor of the *Savannah Morning News* optimistically predicted that "the day is not far distant when Broughton Street will become to Savannah what Broadway is to New York—the shopping promenade of the ladies—occupied with stores from Broad Street on the west, as least as far east as the Marshall House." (GHS Photo Collection #1361 PH, Box 6, Folder 15, Item 1216.)

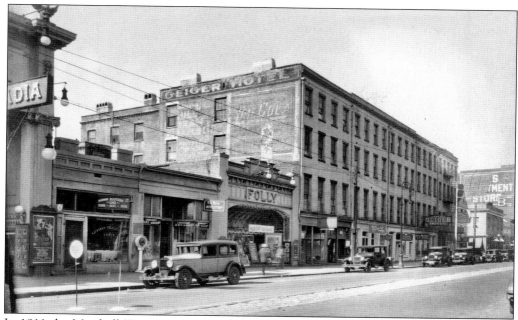

In 1911 the Marshall House was renamed the Geiger Hotel, shown in the photograph above. Notice the bulb sign over the main entrance. By this time the hotel's famous veranda had been removed. In 1934 the name was changed to the Gilbert Hotel, shown below. The Geiger Hotel sign was removed, and a large vertical neon sign was hung in its place. These photographs also show the transition of the Folly Theater to the Band Box. The Marshall House underwent an extensive restoration in 1999, including a reconstruction of the veranda. (Above: Cordray-Foltz Collection #1360, Box 10, Folder 1, Item 10; Below: Cordray-Foltz Collection #1360, Box 10, Folder 1, Item 5.)

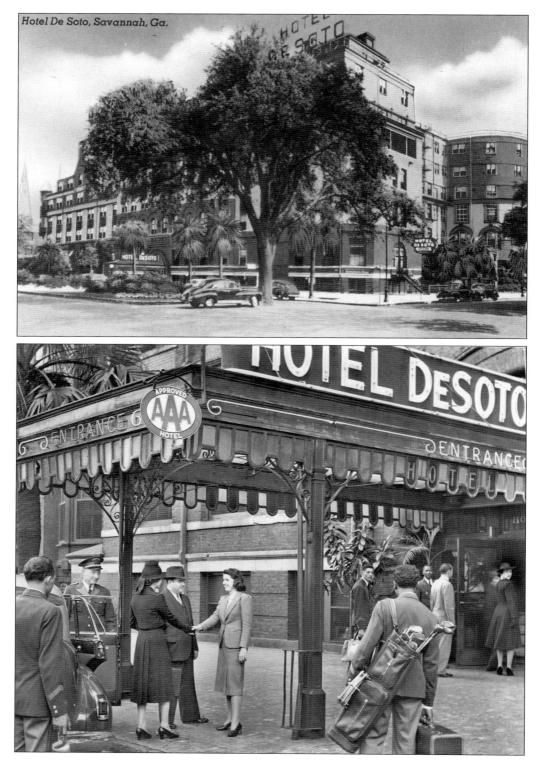

Hotel De Soto, Savannah, Ga.

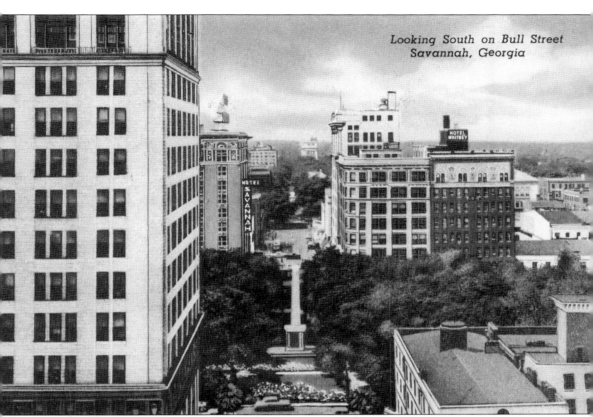

Looking South on Bull Street
Savannah, Georgia

This postcard view looks south down Bull Street from City Hall. Some of Savannah's finest hotels surrounded Johnson Square, the city's first square and center of colonial activities. The roof of the Pulaski Hotel is visible in the right foreground. Opposite the square, to the right of the Germania Bank, stands the Hotel Whitney. The building with the elaborate cornice across Bull Street is the Hotel Savannah. (Author's collection.)

Opposite: During its 75 years of grandeur, the Hotel DeSoto was referred to as the "Dowager Empress of the South," "a superb monument," and "the Queen." A six-floor masterpiece of cultured taste and elegance, the hotel was designed by architect William Preston of Boston. Headed by H.M. Comer, the Savannah Hotel Company spent over half a million dollars to erect this "chief ornament of the city." The hotel threw open its doors on New Year's Day in 1890, and the newspapers described it as a "home-built" structure not to be surpassed. Shown in the postcard is the hotel's rooftop sign, visible for blocks down Bull Street. At the corner a neon sign points to the main entrance on Liberty Street. The dynamic photograph of the entrance shows the neon signage on the glass and metal canopy and bellhops unloading the car of new guests. The DeSoto was razed in 1965 for a new hotel. (Above: Author's collection; Below: Cordray-Foltz Collection #1360, Box 6, Folder 21, Item 1.)

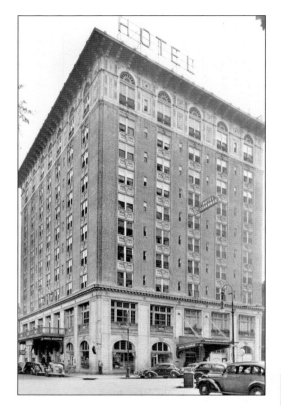

Constructed for the Newcomb Hotel Company, the 200-room Hotel Savannah opened on January 1, 1913. The success of the hotel led to an addition of 100 rooms in 1921. Hotel Savannah was famous for its 10-piece orchestra called the Rathskeller. Since the building was one of Savannah's tallest, the hotel advertised with an enormous rooftop sign. In addition, a sign projected outward from the center of the sixth floor on the Bull Street side of the building. (Cordray-Foltz Collection #1360, Box 7, Folder 3, Item 2.)

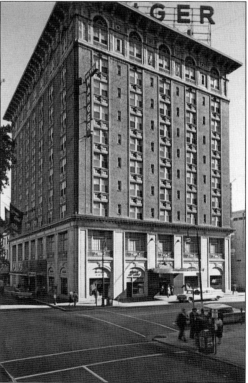

The Manger Management Corporation of New York purchased the hotel in 1954, removed the existing signage, and installed its own. The building operated as the Manger Hotel until the early 1970s. The hotel's luxurious Purple Tree Lounge was a popular spot for locals and tourists. None of the original signs remain, and today the building houses the First City Club of Savannah and business offices. (Author's collection.)

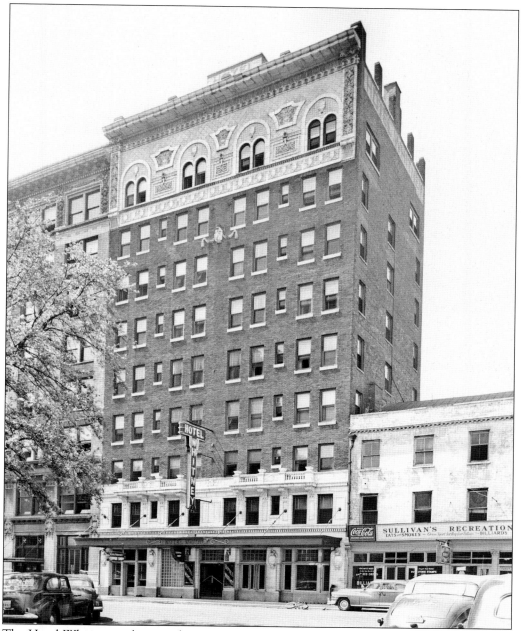

The Hotel Whitney with more than 100 rooms was located at 11 West Congress Street. Built in 1914–1915, the hotel (originally the Hicks Hotel) was constructed for Robert M. Hicks at a cost of $260,000. Rising nine stories to an elaborate cornice, this skyscraper was designed by architect Hyman W. Witcover. Along with the Germania Bank and the Liberty National Bank, the Hotel Whitney was demolished in 1975 for an office building and parking. (Cordray-Foltz Collection #1360, Box 7, Folder 6, Item 10.)

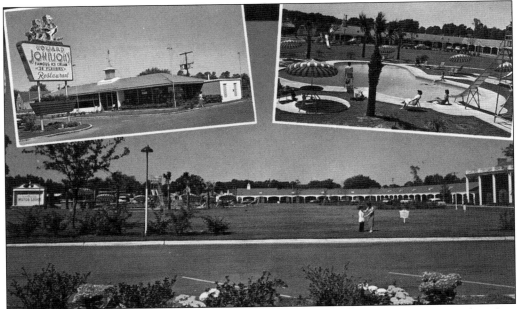

In 1954 Savannah became home to the country's first Howard Johnson's Motor Lodge. One mile south of the city on U.S. Route 17A, Savannah's motor lodge served as an overnight stop for Northeasterners traveling to Florida. A shamrock-shaped swimming pool and a Howard Johnson's Restaurant were also on the grounds. The restaurant had the signature orange roof and a large roadside sign. Simple Simon and the Pieman, Howard Johnson's trademark, topped the neon sign. (Author's collection.)

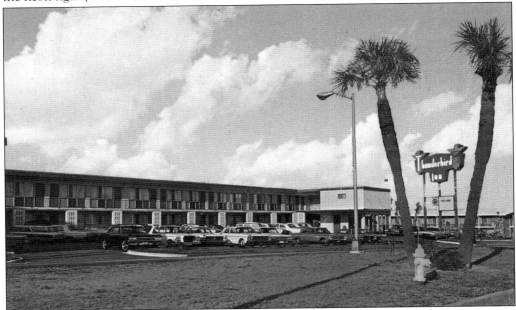

The Thunderbird Inn, owned by Stanley Fulghum, was built around 1965 at the foot of the Talmadge Bridge. The inn continues to operate, and the sign still exists. The sign's multi-colored neon no longer functions. (Author's collection.)

Nine

SHIPPING AND INDUSTRY

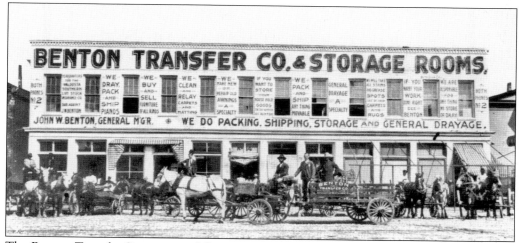

The Benton Transfer Company and Storage Rooms were located at 10–20 West Broad Street. John W. Benton was the general manager, and the company specialized in "packing, shipping, storage, and general drayage." Between each of the building's second-story windows Benton Transfer advertised one of its services. In 1932 the company was incorporated as Benton Brothers Drayage and Storage. Benton Rapid Express was created in 1935, which became one of the South's largest freight truck lines. (Cordray-Foltz Collection #1360, Box 9, Folder 18, Item 1.)

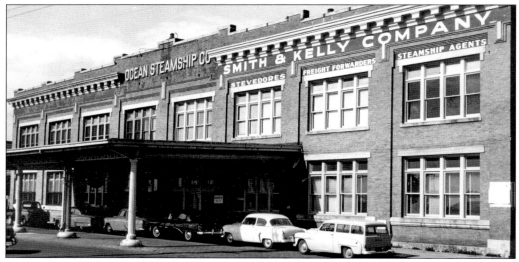

In the year 1870 Capt. Elton Allen Smith and Capt. Lawrence Kelly, masters of sailing schooners, arrived in Savannah. Realizing the potentialities of the port, the sailors entered into the stevedoring business as partners. On July 11, 1890, they were granted a charter, and their business became known as the Smith and Kelly Company. In 1937 the "stevedores," "freight forwarders," and "steamship agents" expanded to larger quarters in the Ocean Steamship Company, Central of Georgia Terminals. (GHS Photo Collection #1361 PH, Box 8, Folder 5, Item 1450.)

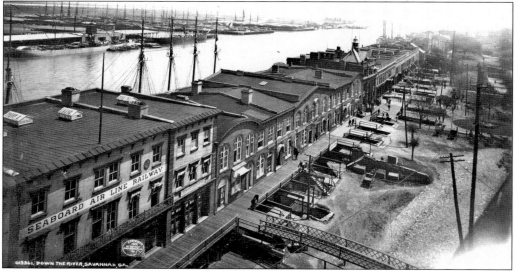

This exceptional photograph, taken by the Detroit Photographic Company, documented Factors' Walk in 1901. The heart of Savannah's cotton and shipping industries, this strip of buildings was composed of countinghouses, warehouses, and offices. The Seaboard Air Line Railway occupied the buildings at the start of the row. The railway offered passenger and freight services and operated extensive marine and rail terminals on Hutchinson Island. These terminals, handling import and export traffic, substantially contributed to the development of the port. Beside the railway's offices was the John Flannery Company, a cotton factor. (GHS Photo Collection #1361 PH, Box 8, Folder 15, Item 5824.)

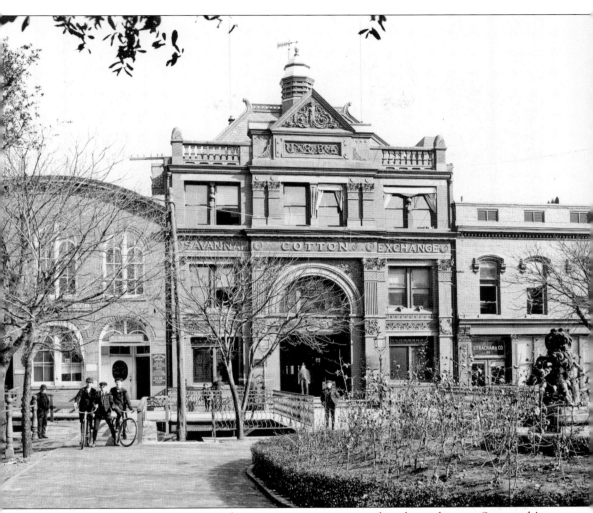

During Reconstruction, cotton was the most important commodity shipped across Savannah's wharfs. At its peak in the 1880s the port of Savannah exported more than two million bales of cotton each year. Designed by William G. Preston and constructed in 1886–1887, the Savannah Cotton Exchange was a world center for the cotton trade. When market reports came in from New York, New Orleans, and Liverpool, the Exchange filled with factors and exporters. However, by the late 1920s, falling cotton prices and the boll weevil left Georgia's agricultural economy on the brink of collapse. Cotton was no longer "king," and an era of commercial vibrancy along Factors' Walk ended. Obsolete for its intended use, the building is currently used by Solomon's Lodge Number 1. (GHS Photo Collection #1361 PH, Box 7, Folder 10, Item 1284.)

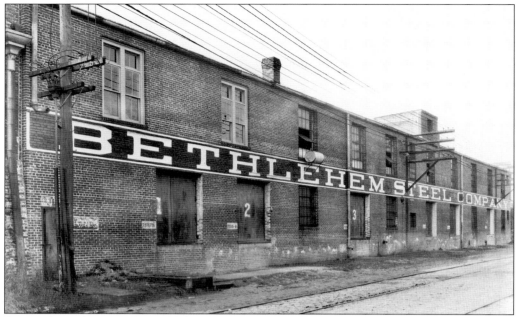

During the early 1940s the Bethlehem Steel Company used this 534 West River Street building to distribute steel products brought to Savannah's port. Previously, the building served as the warehouse for J.D. Weed Wholesale Hardware, established in 1816. (Cordray-Foltz Collection #1360, Box 12, Folder 22, Item 1.)

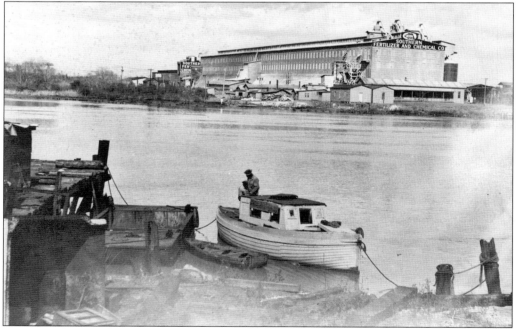

This riverside plant, identified by the wall painting in the structure's gable, housed the Southern Fertilizer and Chemical Company. Sulphuric acid, superphosphate, and fertilizers were produced here. (GHS Photo Collection #1361 PH, Box 20, Folder 4, Item 4039.)

Ten
TRANSPORTATION

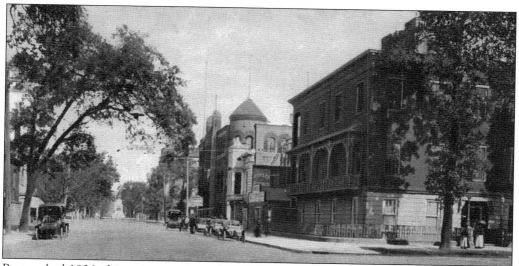

Postmarked 1906, this souvenir postcard is titled "Bull Street, from Monterey Square." A line of Packards is parked in front of the bicycle shop and car dealership of T.A. Bryson. Just beyond Bryson's building is the Savannah Volunteer Guards Armory, designed by William G. Preston and built in 1893. Both buildings are now owned by the Savannah College of Art and Design. (Author's collection.)

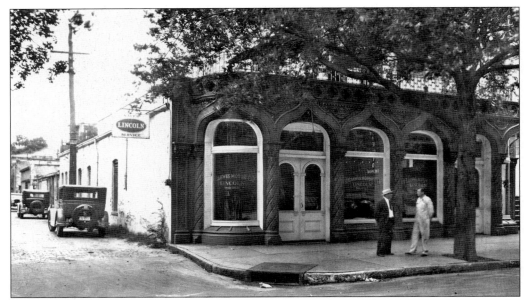

Established in 1912, the J.C. Lewis Motor Company was one of Savannah's pioneers in the automobile industry. Pictured above is the company's first location at 309 Bull Street. The signage on the building reveals that J.C. Lewis originally sold Lincoln automobiles. This architecturally eclectic building with its terra-cotta and plate-glass façade was home to the company until 1918. J.C. Lewis then moved to the southwest corner of Oglethorpe Avenue and Barnard Street. The garage and salesroom shown below was later constructed to house the growing Ford dealership. In the mid-1930s J.C. Lewis employed a corps of 60 salesmen, repairmen, parts experts, and clerks. The business continued to expand through the years and has grown into one of Savannah's largest car dealerships. (Above: Cordray-Foltz Collection #1360, Box 10, Folder 24, Item 9; Below: Cordray-Foltz Collection #1360, Box 12, Folder 17, Item 2.)

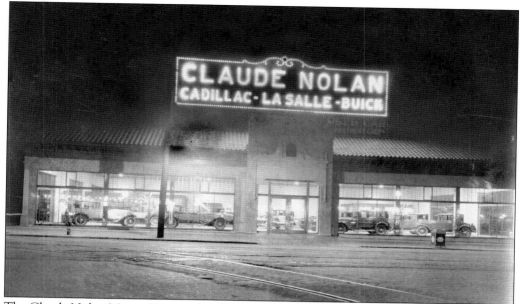

The Claude Nolan Motor Company's offices and salesroom were located on West Broad Street at the terminus of Broughton Street. The dealership sold and serviced Cadillac, La Salle, and Buick automobiles. Illuminated with hundreds of incandescent bulbs, the ornate rooftop sign was visible for blocks down Broughton. After purchasing the building in 1934, Firestone modified the building by demolishing the glass display walls and the Spanish Mission–style entranceway. Firestone removed the Claude Nolan advertisement from the sign's steel framework and installed the corporation's own neon lettering. Although this building was destroyed, Firestone continues to operate a service station at this location. (Above: Cordray-Foltz Collection #1360, Box 9, Folder 22, Item 3; Below: Cordray-Foltz Collection #1360, Box 9, Folder 18, Item 16.)

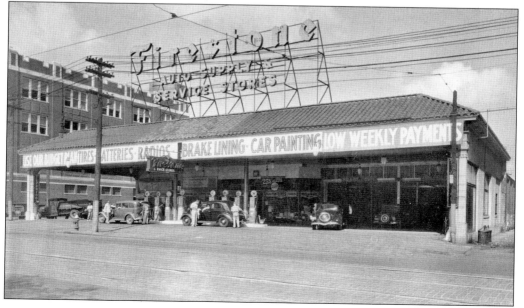

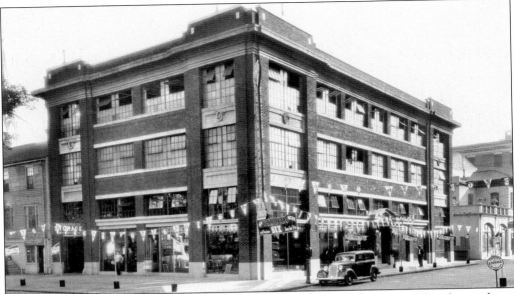

The Chatham Motor Company, owned by the Kaminsky Brothers, was located at the southeast corner of Liberty and Drayton Streets. Before moving to this location, the company was at 349 Bull Street. A three-story vertical sign was mounted at the building's corner to catch the attention of motorists on both streets. Architectural symbolism in the form of winged tires adorned the recessed panel below the fourth-story windows. The building still exists, but it is no longer home to the Plymouth and Chrysler dealership. (Cordray-Foltz Collection #1360, Box 12, Folder 10, Item 10.)

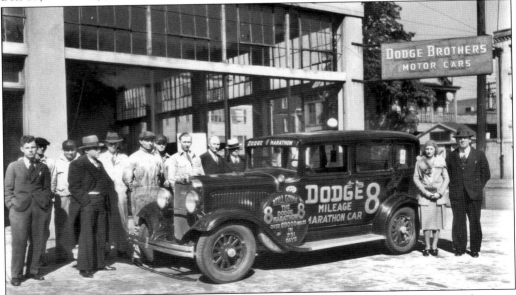

The Savannah garage pictured above serviced Dodge motor cars. The mechanics and owners posed beside their "Dodge Mileage Marathon Car" for the 1930 photograph. As indicated on the spare tire cover, the Number 8 car had traveled 690,000 miles in 231 days. (Cordray-Foltz Collection #1360, Box 6, Folder 4, Item 6.)

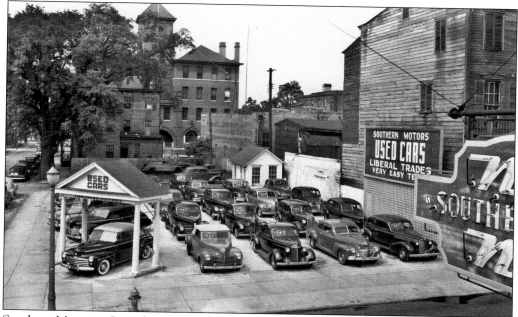

Southern Motors at Lincoln and East Broughton Streets was owned by the Kaminsky family. In the photograph above, the dealership's neon sign is visible at the middle of the picture's right edge. Southern Motors' used car lot was across Broughton Street at the northeast corner of the intersection. In the late 1960s Southern Motors relocated its showroom a block further east to the intersection of Habersham and East Broughton Streets. By this time, interior-lit plastic signs had taken the place of neon. Southern Motors is still in business on Broughton Street, selling new and used cars. (Above: Cordray-Foltz Collection #1360, Box 10, Folder 5, Item 2; Below: Historic Savannah Foundation.)

Facing Reynolds Square, the Motor Supply Company building at 28 Abercorn Street was erected in 1926. The business was established in 1919 and maintained a wholesale policy, dealing only with garagemen, automobile dealers, and service stations. In the late 1940s the parts house relocated to 37 West Broad Street. Branches existed in Augusta, Brunswick, and Waycross, Georgia, and Aiken, South Carolina. (Cordray-Foltz Collection #1360, Box 9, Folder 1, Item 1.)

Established in 1898, the Frank Corporation at 322 West Broughton Street first sold harnesses, bridles, bits, and braces. Auto parts were introduced into the company's stock in 1919. The two-story wall painting advertised the Frank Corporation as a supplier of "wholesale automotive replacement parts, accessories, and shop equipment." In 1960 the Frank Corporation went out of business, and the building became the home of Beberman's Furniture. (Cordray-Foltz Collection #1360, Box 10, Folder 18, Item 11.)

This 1934 photograph of 401–409 West Liberty Street shows the Auto Service Station, the Sandwich Shop, and the Dutch Kitchen. The Auto Service Station sold Gulf gasoline. Notice the Gulf logo on the pole sign and painted above the service bay. The street front of the Sandwich Shop was loaded with signage for Coca-Cola and Jax soda. (Cordray-Foltz Collection #1360, Box 12, Folder 12, Item 11.)

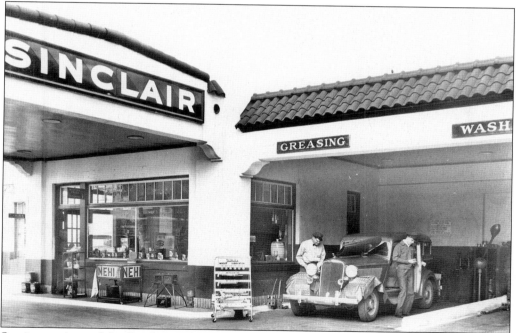

Service stations of the Sinclair Refining Company were located throughout Savannah in the 1930s. This 1935 photograph is of the station at the intersection of West Broad and West Bay Streets. Service stations during this period took stylistic influences, such as tile roofs and stucco walls, from Spanish architecture. (Cordray-Foltz Collection #1360, Box 9, Folder 22, Item 2.)

The Eveready Service Station, located at 431 Whitaker between Wayne and Gordon Streets, sold Quaker State motor oil and Texaco gasoline. The Texaco Star decorated the glass globes of the gas pumps and the hanging sign. The Texaco Fire Chief logo adorned the gas pumps. (Cordray-Foltz Collection #1360, Box 13, Folder 19, Item 5.)

Boyd Tire Company, on the east side of Drayton between Hull and McDonough Streets, served as a gas station, tire supplier, and car storage facility. As advertised on the wall paintings, the company sold Pan-Am gasoline and Fisk brand tires. Outlined with bulbs, the company's hanging neon sign called to drivers motoring down Drayton Street. This building was rehabilitated and currently houses Parker's Market, a gourmet grocery and gas station. (Cordray-Foltz Collection #1360, Box 11, Folder 12, Item 4.)

In June of 1938 the Greyhound Bus Depot moved from its Bull Street and Broughton Lane location to its new streamlined building at 109 West Broad Street. Financed by Horace P. Smart and built by the Artley Company, the modernistic terminal was considered one of the handsomest in the South. According to a *Savannah Morning News* article, the building was constructed of "brick and steel with vitrolux, vitrolite and weather-resistant enamel finish." Aluminum and neon tubing faced the marquee, and at its south end rose a 25-foot vertical sign surmounted by a cast aluminum, animated greyhound. Behind the large plate-glass window, a restaurant ran the length of the building's front as shown below. The rear of the building included a waiting lobby, offices, and restrooms. In 1965 Greyhound built a new station around the corner on West Oglethorpe Avenue, abandoning this depot. The building has remained largely vacant over the years, causing significant deterioration. Neither the vertical neon sign nor the freestanding neon awning letters survive. (Above: Cordray-Foltz Collection #1360, Box 9, Folder 19, Item 6; Below: Box 9, Folder 19, Item 8.)

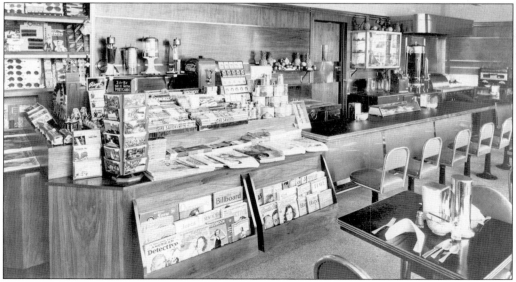

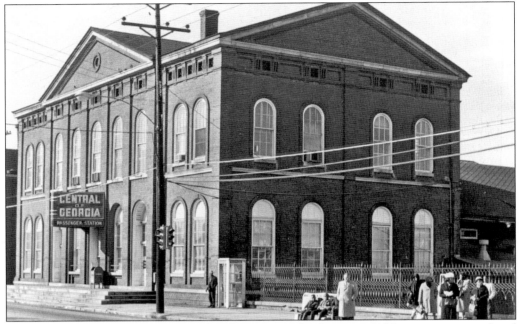

Central of Georgia, the state's first railroad, was granted a charter in 1833 to construct a railroad from Savannah to Macon. Completed in 1843, this run of track was the longest in the world under one management, a distinction held for a period of 10 years. The railroad continued to expand its coverage, laying track throughout Georgia and into Alabama and Tennessee. This Central of Georgia Railroad building at 301 West Broad Street was designed by Augustus Schwaab in 1860 and completed in 1876. The building served as the railroad's passenger station. During the 1950s and 1960s Central of Georgia was famous for its streamliner *Nancy Hanks II*. Traveling on the train to Atlanta was referred to as "Southern hospitality on wheels." Central of Georgia left the building in the early 1970s. In 1974–1975 the building and its train sheds were rehabilitated into the Savannah Visitors Center and Chamber of Commerce. (Historic Savannah Foundation.)

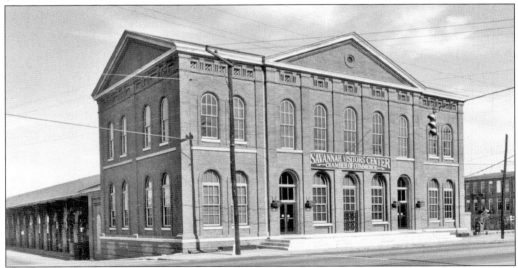

INDEX

Adler, Leopold, 9
Adler, Robert, 10
Adler, Sam, Jr., 10
Adler, Sam, Sr., 10
Adler's Department Store, 9, 10
Advanced Refrigeration Company, 37
A. Levy & Son, 29
Alexander, Henry R., 64
Alexander Grocery Company, 64
Allen, J. Henry, 42
Annette's Dairy, 68
Arcade Pool Room, 73
Arcadia Theater, 101, 102
Art Sign Company, 4
Avon Theater, 102
Band Box Theater, 102, 107
Bart, C.A., 72
Bart's Bakery, 72
Beberman Furniture, 36, 122
Bell, Malcolm, 10
Benton, John W., 113
Benton Transfer Company, 113
Bethlehem Steel Company, 116
Bijou Theater, 99, 101
Blumberg Brothers, 16
Bo Peep's, 83
Boyd Tire Company, 124
Bradley, Simon, 49
Bradley Lock and Key, 49
Branch & Cooper Groceries, 55
Bristol Lunch, 73
Bryson, T.A., 117
Burns and Harmon, 40
Butler's Shoes, 27
C.D. Kenny Company, 17
Canton Chinese Restaurant, 79
Caroline Hat Shop, 20, 21
Central of Georgia, 126
Chatham Motor Company, 120

Chatham Styled Furniture, 36
Citizens Bank, 54
City Market, 58, 59
Claude Nolan Motor Company, 119
Cohen, Joe, 22
Cohen, Louis A., 22
Cohen, Samuel A., 22
Cohen, William, 22
Coastal Coffee Company, 65
Coca-Cola Bottling Company, 67
Cotton Exchange, 115
Davenport House, 58
Derst, John, 71
Derst, Edward J., 71
Derst Baking Company, 71
Desbouillons, 28
Desbouillons, Aristides Louis, 28
Dilworth, Frank A., 26
Dixie Crystals Sugar, 70
Dixie Pawn Shop, 32
Dodge, J. B., 77
Donaldson, Kermit, 81
Drive-In Theater, 104
Dunbar Theater, 97
East Coast Paint Company, 42
Entelman, J. H. H., 56
Eveready Service Station, 124
Factors' Walk, 114, 115
Figg, Leona, 84
First Federal Savings Bank, 102
Firestone, 119
Fluke, Meyer, 10
Folly Theater, 101, 102, 107
Fox and Weeks, 47
Frank Corporation, 122
Frank's Shoe Repair Shop, 26
Frech, Henry C., 85
Frech's Pharmacy, 85
Free Brothers Laundry, 50
Friedman, Benjamin, 31

Friedman's Jewelers, 31
Geffen, Joseph, 90
Geiger Hotel, 107
George, Jerry, 75
Georgia Historical Society, 2, 6
Georgia Ice Company, 38
Georgia Supply Company, 41
Germania Bank, 109, 111
Gilbert Hotel, 107
Globe Shoe Company, 23, 24
Greyhound Bus Depot, 125
Griffin, dentist, 45
Grocerteria, 60
Gryphon Tea Room, 87
Gulf Service Station, 123
Harms Dairy, 48, 68
Harris, Lester, 20
Haverty's, 33
Historic Savannah Foundation, 58
Hitt, A.M., 86
Hodgson Hall, 2, 6
Hotel DeSoto, 108
Hotel Manger, 110
Hotel Savannah, 83, 109, 110
Hotel Whitney, 109, 111
Howard Johnson's Motor Lodge, 112
Howell, Claude K., 35, 98
Hub Clothing, 20, 21
Hutcheson's Food Store, 61
Innecken Florist, 39
International Milling Company, 72
J.A. Tison's Sons, 42
J.C. Lewis Motor Company, 118
J.C. Penney, 10, 14
Joe Cohen and Sons, 22
John Flannery Company, 114
John M. Harmon and Son, 40
Johnny Harris Restaurant, 81
Jones, Walter D., 86
Jones Company, 22
Jones' Pharmacy, 86

J. S. Pinkussohn Cigar Company, 64, 93, 94, 106
Kahrs, Jimmie, 93
Kaminsky, 120, 121
Kelly, Lawrence, 114
King's, 74
Knight's Drug Company, 88
Kraft, Carl J., 22
Kress, 16, 17
Kress, Samuel H., 15
Lang's Shoe Shop, 25
Leopold Brothers, 76
Leopold family, 76
Lerner Shops, 19
Levy, Aaron, 29
Levy, Arthur B., 11
Levy, B.H., 11, 12
Levy, Morris, 18
Levy, Sidney H., 11
Levy Jewelers, 30
Levy's Department Store, 11, 12
Lindsay & Morgan Company, 35
Lindsay, Gilbert, 35
Lindsay, James, 35
Lindsay, W.J., 35
Livingston's Drugs, 89
Lucas, Arthur, 35, 98, 99, 101
Lucas Theatre, 98
Lyons Building, 20, 45, 55
Maas Brothers Department Store, 12
Marshall House, 106, 107
Melody Theater, 103
Meyer's Tobacco Shop, 91
McEllinn, Thomas J., 48
McIntyre, W.R., 86
McIntyre & Hitt Pharmacy, 86
Mathews, Frank C., 63
Maxwell Brothers and Asbill, 34
McCrory's, 15
Monsees, C.H., 57
Morgan, David B., 35
Morris Levy's Store for Men and Shop for Women, 18
Motor Supply Company, 122
Moyle, Edward, 20
Moyle Trunk and Bag Company, 20

Nat's Beer Parlor, 82
Neal-Blun Company, 41
Nichols Shoes, 24
None Such Café, 74
Ocoma Garage, 64
Odeon Theater, 101, 102
Oliver, C.E., 69
Olympia Restaurant, 73
Owl Drug Company, 90
Parisien Beauty Parlor, 44
Perlman, Hymie, 26
Perlman, Morris, 26
Peters, E.B., 66
Peters, P.F., 66
Peters Bottling Company, 66
Plaza Restaurant, 78
Pope's Barber Shop, 43
Pulaski Hotel, 105–106, 109
Preston, William, 108, 115, 117
Randolph's Hi-Grade Vegetables, 62
Reverend Bailey's Shoe Shop, 25
Rico Theater, 104
Rimes, Troy T., 20
Rogers Market, 59
Royall, William H., 47
Royall Company, 47
Roxy Theater, 100, 102
Saussy, Hunter, 10
Savannah College of Art and Design, 12, 87, 100, 117
Savannah Electric Company, 52, 53
Savannah Morning News, 51
Savannah Sugar Refinery, 70
Savannah Theater, 95, 96
Savannah Tobacco Company, 92
Savarese, 63
Schulte-United, 14
Schwaab, Augustus, 58, 126
Schwab, I.M., 46
Scott, Walter Sanford, 97
Seaboard Air Line Railway, 114
Sears, Roebuck and Company, 13, 14
Seckinger & Garwes, 48
Silver, Wolfe, 83
Silver's, 17

Simon, Sandy, 10
Sinclair Refining Company, 123
Singleton, John, 10
Smith, Elton Allen, 114
Smith and Kelly Company, 114
Solomons, Abraham, 87
Solomons Company, 87
Southern Fertilizer and Chemical Company, 116
Southern Motors, 121
Starland Creamery, 69
Star Laundry, 50
State Theater, 102
Stubbs, Otis, 40
Stubbs Hardware Company, 40
Super Market, 59
Tash Rovolis Confectionery, 29
Tenenbaum, George, 17
Tenenbaum, Max, 17
Tenenbaum, Michael, 17
Tenenbaum's, 17
Theater Soda Shop, 75
Thirst Station, 77
Thomas, Roy, 87
Thunderbird Inn, 112
Tommies Place, 84
Tuten, Terrell T., 22
Victory Theater, 103
Walker-Mulligan Furniture Company, 34
Weed, J.D., 116
Weinberg, Nat, 82
Weis, Albert, 96
Weis, Fred G., 96, 100, 102
Weis Theater, 100
Western Union, 54
White, John F., 39
White Hardware, 39
White House Restaurant, 80
Williams family, 80
Williams Seafood, 80
Wilson & Company, 65
Wilson's Confectionery, 61
Woolworth, F.W., 14, 15, 102
Wu, John, 79
Wu, Lancy Sheng, 79
Yachum & Yachum, 26